HOW TO PAINT
PASTELS

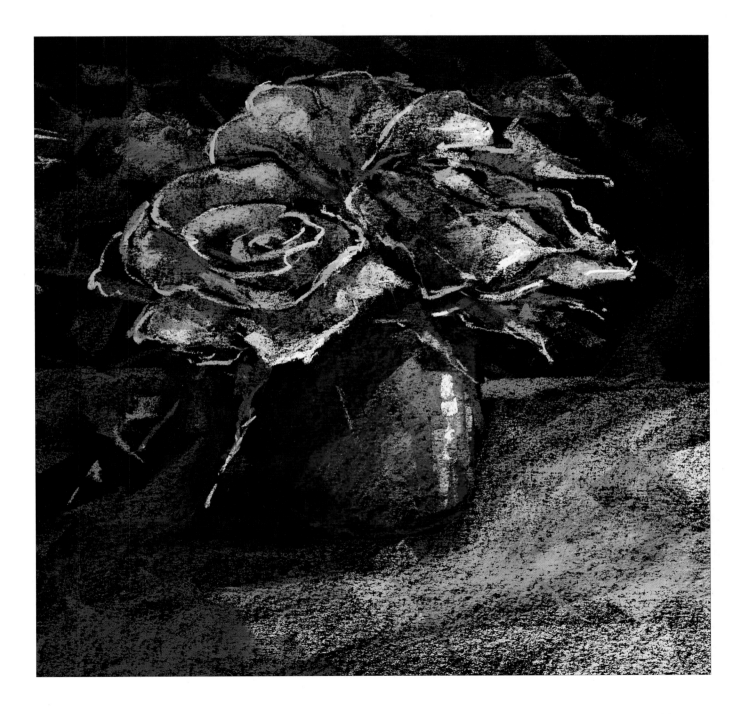

Dedication

To my family, Brian, Thys and Nina.

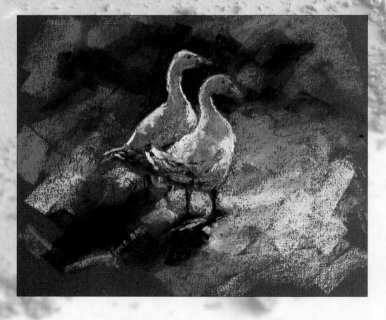

HOW TO PAINT
PASTELS

CAROL HODGSON

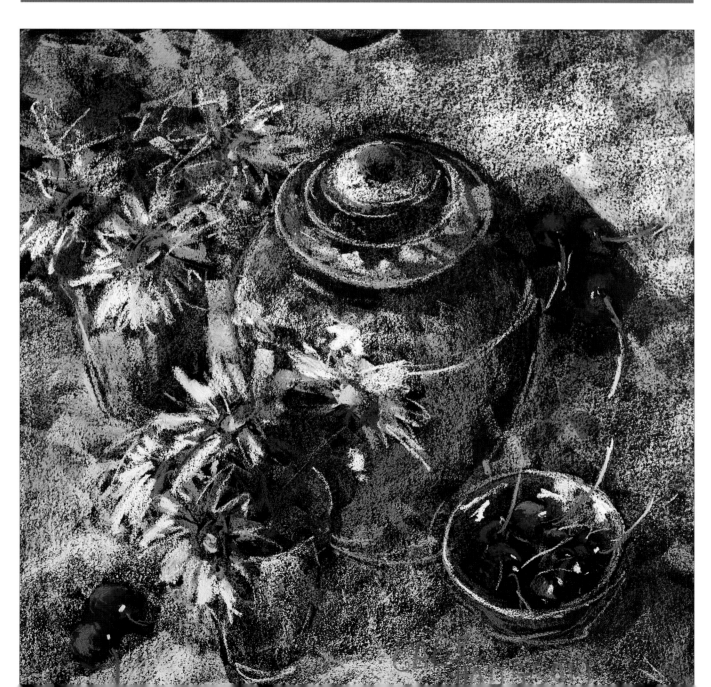

First published in Great Britain 2009

Search Press Limited
Wellwood, North Farm Road,
Tunbridge Wells, Kent TN2 3DR

Text copyright © Carol Hodgson 2009

Photographs by Roddy Paine Photographic Studios

Photographs and design copyright © Search Press Ltd. 2009

ISBN: 978-1-84448-365-5

The Publishers and author can accept no responsibility for
any consequences arising from the information, advice or
instructions given in this publication.

Suppliers
If you have difficulty in obtaining any of the materials
and equipment mentioned in the book, please visit
www.winsornewton.com for details of your nearest
Premier Art Centre.

Alternatively, please phone Winsor & Newton
Customer Service on 020 8424 3253.

Publishers' note

All the step-by-step photographs in this book feature
the author, Carol Hodgson, demonstrating pastel
techniques. No models have been used.

Printed in Malaysia

Acknowledgements

*Thank you to the Search Press team,
particularly Juan for great design and
Sophie Kersey for her guidance and ability to
put my words into some semblance of order.*

Cover
Sunlight on the Val d'Arno
39 x 39cm (15³⁄₈ x 15³⁄₈in)

Page 1
Yellow Roses
25 x 25cm (9⁹⁄₈ x 9⁹⁄₈in)

Page 2
Two Geese in the Sunshine
20 x 18cm (7⁷⁄₈ x 7in)

Page 3
Blue and White Still Life
40 x 40cm (15³⁄₄ x 15³⁄₄in)

Page 4
It Takes Two, Baby
18 x 18cm (7 x 7in)

Contents

Introduction

'How to paint' might be a curious title for a book about pastels, as one generally relates paint to a wet medium that is applied with brushes. In this case, the medium is not wet and brushes are not required, in fact very few tools are needed for the pastel painting process. Even so, with effective applications you can achieve results rivalling those of any traditional painting medium and with tremendous vibrancy of colour.

Mention the word pastel, and to some it musters up visions of pale, pretty colours; pastel is far from this. Of course you will find beautiful, pale tints in the enormous range of colours that manufacturers produce, but there will also be every conceivable hue and shade. When I hear the word pastel mentioned, I have visions of vibrant, brilliant colour and exciting, energetic strokes, which make me want to pick up pastels and begin to paint.

Refer to any manual on oil painting and it will contain terms such as impasto and scumbling; any watercolour handbook will describe techniques such as transparent washes and glazes. These techniques and more are also included in the repertoire of applications used by the pastel artist but with one essential difference, that no brush is required. With this freedom comes the reward of immediacy and spontaneity – you just need a confident hand and the ability to manipulate the pigment.

As with any medium, you need to build confidence in the application and understanding of pastel. In this book I have included information on the medium and techniques of application to help you develop the skills to go on to produce your own paintings. I am a believer in taking an experimental and playful approach to learning and recommend that you try the techniques first without subject matter, and as you acquire new skills, put them into practice in a painting.

I admit that pastel does have one or two detrimental features, but to understand them is to master them. The fact that muddy colours can easily occur is one problem that artists encounter, so I have included some tips on how to overcome that. Again, try making those mistakes through experimenting; it is far better to discover them and learn how to deal with them by trial and error than on your precious picture.

Over recent years there has been a resurgence of interest in pastel, with artists producing a fantastic array of styles and techniques. I am a great believer in developing your own style and think that the experimental approach applies here too. However, looking at other artists' work helps, not only for the fantastic inspiration it gives, but also because it helps you to understand how they approach and convey information through pastel application. Armed with your new-found knowledge of techniques and materials, I hope you will attempt the demonstrations in this book, and through a guided, step-by-step approach, take the next step on to developing your own unique style.

Sunflowers with Pears
43 x 45cm (17 x 17¾in)

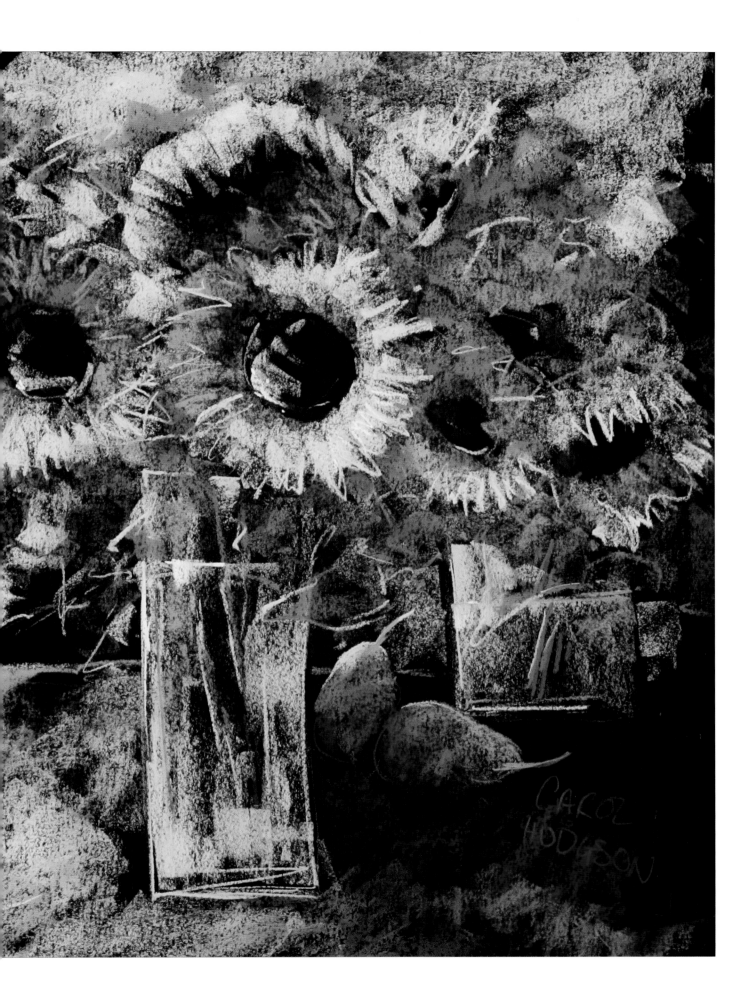

Materials

Pastels

Essentially there are two grades of pastel, hard and soft. I have used the soft variety throughout the book, but within that category the relative consistency varies greatly, with some pastels being much softer than others. This is entirely due to the chemistry of the product, which is a combination of pigment, binding agent such as gum tragacanth and varying amounts of chalk. Chalk will effect the strength of the base colour with a lot added to create a light tint and less for a darker shade. Some colours require more pigment than others, resulting in a firmer textured pastel, whereas some require less and are much softer.

A result of the manufacturing process is that each brand has its own unique identifying characteristics. If they are machine made, then they will have a uniform, straight appearance, whereas some brands are made and rolled by hand and consequently have a curved shape to them. A useful feature of Winsor & Newton pastels is that they include the colour and tint number on the label whereas some brands only print the number. However, each pastel has an individual quality and for that reason artists quite often accumulate pastels from a variety of brands.

Pastels can be purchased in sets or as individual sticks. Buying them as single sticks can be somewhat overwhelming with such a tremendous colour choice – some manufacturers produce 300 or more. As a general guide to start with, buy a base colour with a lighter tint and a darker shade of the same colour. Alternatively, buying sets reduces the confusion; all manufacturers produce a set of assorted colours and some have specifically selected collections to suit the landscape or portrait artist. I would advise starting off with a handful of pastels to experiment with before moving on to a more comprehensive set.

Surfaces

There is a fantastic array of paper types and surfaces available to the pastel artist, with the prerequisite being that they have a certain amount of 'tooth' for the particles to attach to. Avoid using smooth paper as it will not grip the particles and with time the pastel would simply fall off.

Most papers are recognisable as a specific brand because of the texture resulting from the manufacturing process: they may have an even tooth or a pattern running through them.

Mi-teintes paper

Mi-teintes paper has a honeycomb like appearance. Notice how the applied pastel highlights the honeycomb texture.

Textured paper

In some cases the texture is sprayed on. This creates a granular surface similar to that of sandpaper, but with a slightly uneven surface.

Sandpaper

Sandpaper specifically made for the art market has much the same surface as that made for the carpentry trade. It has a granulated surface that holds the pigment extremely well and allows the build-up of many layers of pigment. The marks shown here are using the side of the pastel, but this surface is also perfect for using the end of the pastel for heavier impasto techniques.

Making your own surface

There are several products on the market for texturing your own surface. These texture gels or pastes generally comprise an acrylic gel or gesso with grit, sand or pumice added. When they are applied to a support such as hardboard or mountcard with a brush or palette knife, very interesting textures are created.

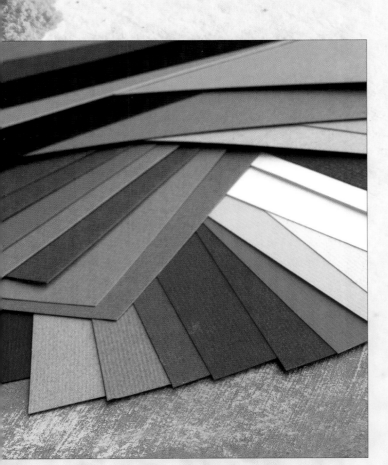

Paper colour and tone

This is as important as texture when choosing paper, and there is plenty of choice available: Winsor Universal Pastel Paper comes in twenty-five colours. Paper colour will influence the eventual outcome of a painting because the pastel never totally impregnates the surface texture, so some of the colour will always show through. This has a unifying effect to the overall picture, which is particularly helpful when a broad colour palette is used.

When choosing paper, consider the following:
Colour temperature – there are cool colours, which recede, or warm colours, which tend to come forwards.
Harmonising colours – this effect is achieved if the paper and the predominant colour palette of the pastels are the same, in the same colour family or next to one another on the colour wheel, with a resulting subdued feel.
Contrasting colours – use opposites on the colour wheel for a more vibrant outcome.

Other materials

Pastel is a medium of simplicity and convenience in that very few materials are necessary other than pastels, paper and a firm surface to work on. However, some extra materials have evolved into my painting routine.

A **painting board** provides the surface to work on and is large enough for a big sheet of paper, which is clipped to it. The **large clips** hold the paper in place and also attach various pieces of source material such as sketches and photographs to the board for easy reference.

Kitchen paper is perfect for cleaning a pastel stick with a gentle wipe before returning it to its storage container or applying to a painting, and it should always be within reach for hand cleaning. It is also useful as padding for protection in the base of my palette, and I put a few sheets on the tray of my easel to catch any falling dust.

Fixative is crucial to my painting method (see pages 16–17). In addition to fixing pigment during the painting process, it can also be used to knock back colour, should you find that you have been overly generous with it. An added benefit of using fixative is that it raises the tooth of the paper, increasing texture for subsequent layers of pastel.

My repertoire of extra materials includes **pastel pencils** used for sketching, the initial drawing of a painting and occasionally for finer detail. Be aware that they will not work over the top of heavily applied pastel, as they are generally quite hard and require a good amount of tooth to attach to.

A **putty eraser** is used for correcting mistakes, but keep a wad moving about in your hand to help you remove pastel dirt as well. This looks just like a traditional eraser, but once it is out of the packaging, you discover that it is pliable and can be moulded into different shapes, making it particularly useful for very small areas, as it can be formed into a sharp point. It can be dragged to rub out the pastel and it can also be dabbed on to the surface to lift off the pastel. The beauty of this product is that it does little or no damage to the texture of the paper in the way that a traditional hard eraser can.

A **paintbrush** is used for dusting off mistakes (see page 19).

Hand cream is an essential as I regularly wash my hands while painting and consequently they are very dry – a common complaint for pastel artists!

Texture gel or paste is applied to a surface such as mountcard or hardboard to create a textured surface on which to use pastels (see page 9).

A **sketchbook** and **pencil** are used for sketching and planning (see pages 22–23).

Kitchen paper used to line the plastic container I use as a palette.

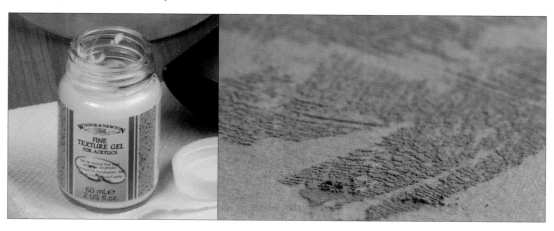

Texture gel, used to create your own textured surface.

Opposite

A painting board, clips, fixative spray, putty eraser, sketchbook, paintbrush, pencil and pastel pencils.

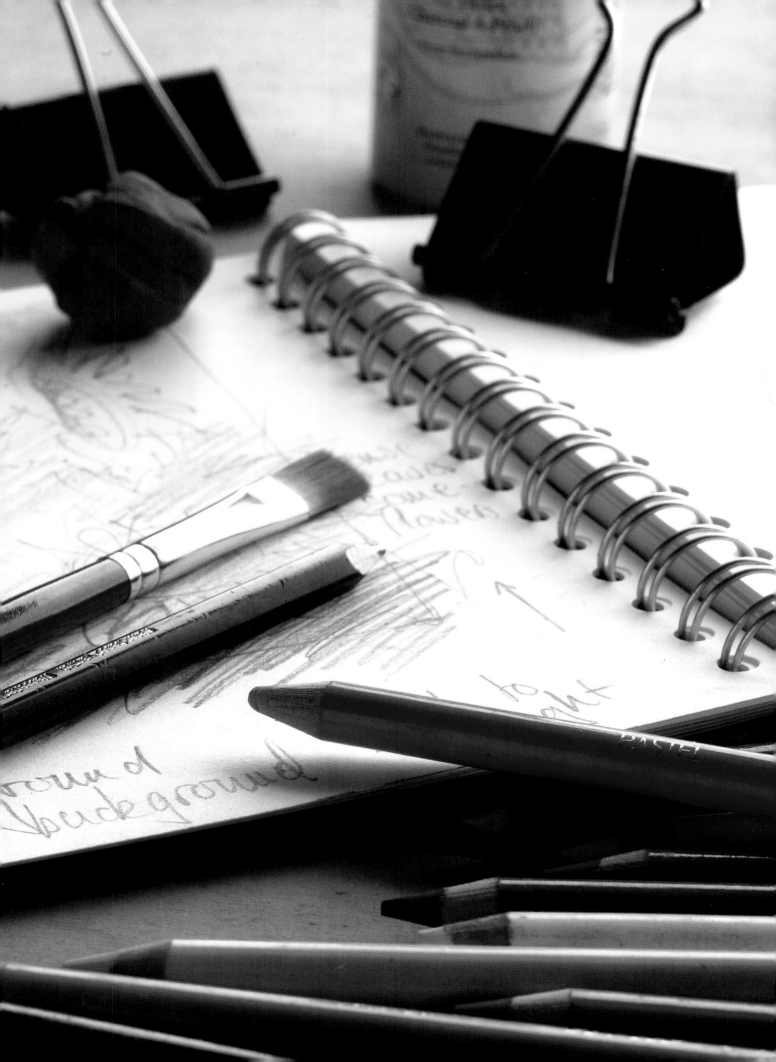

Techniques

The method of application is as important in developing a unique identity to your work as the subject, composition and design. The following pages describe several application techniques I suggest you experiment with. Initially practise without a subject to gain confidence, then as your ability improves, graduate to simple subject matter such as the blended landscape on pages 14–15 and the flowers on pages 16–17.

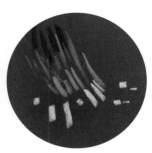

Making marks

Using the end of the pastel stick

This is a very direct method that can achieve a likeness or effect instantly. With firm strokes, you can replicate the impasto effect like that of an oil painting, or with a lighter touch, delicate marks can be applied. I use these techniques towards the latter stages of my paintings to create interest and variation of marks, however all of the techniques shown here can be used individually or combined.

The pears (below) were created with heavy impasto strokes using the end of the pastel stick. Notice how the marks follow the contours of the fruit and contribute along with tone to the round shape. To create the design on the fabric, delicate lines which complement the shape of the pears were added along with dots of dark blue and white for further interest.

Delicate lines.

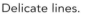

Heavy impasto marks.

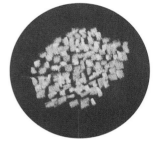

Dots of contrasting colours.

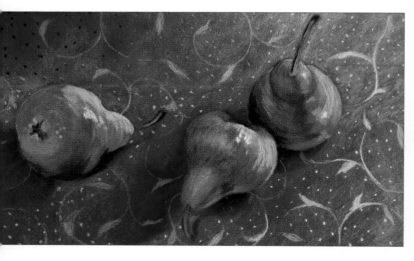

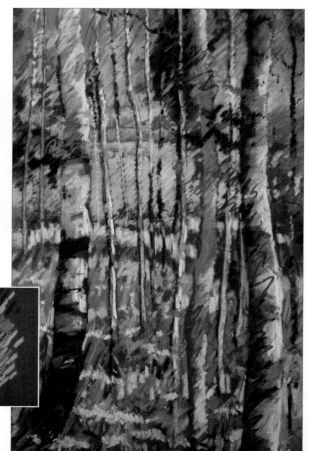

Birchwood
Short linear marks were used to make this painting. For interest they varied between diagonal, vertical and horizontal.

Using the side of the pastel stick

Of all the techniques, this one is the most expressive way of applying pastel. Large areas can be covered quickly with broad sweeps of the pastel and interesting marks can be created. A gentle sweep of the side of the pastel, depositing a light layer, will leave enough existing tooth on the paper for several layers to be applied. Alternatively a heavy application can be made for immediate intensity of colour, but this will fill the grain of the paper very quickly, so the number of layers applied is limited.

Remove the paper from the pastel to access the side of the stick and possibly break it in half to achieve a flat edge. Take extra care not to hold the pastel too firmly, as this might cause it to crumble.

Tip

Make a chart of the pastel tints as you remove the paper covering so that you have a record to remind you of what colours you use when re-ordering.

Lavender Field

Virtually all the marks made in this small painting used the side of the pastel stick with the addition of a few dots and dashes to suggest the detail of the buildings. Notice how the paper is showing through, with the benefit of unifying the colours.

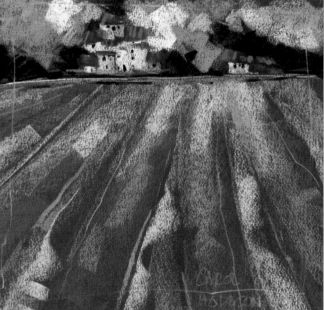

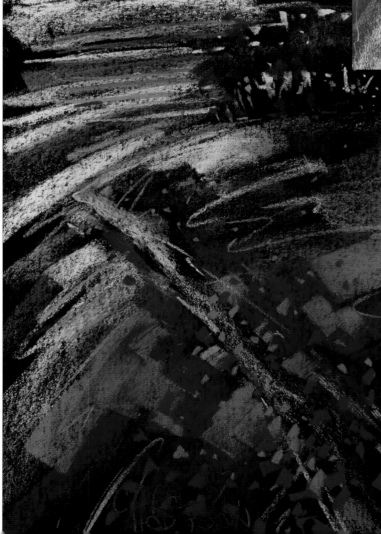

Red and Green Landscape

Here I have combined two techniques: broad sweeps of colour in a diagonal direction and contrasting gestural strokes using the end of the pastel.

13

Blending

The basic method of blending is to rub the pastel with your fingers into the grain of the paper, spreading and blending the pigment. It is useful for large areas and as an underpainting in preparation for further application techniques. It can achieve realistic effects and gradations of tone, useful in developing shape and form. I rarely use it, as I prefer more texture in my work, however it does achieve useful effects so I consider it worth including.

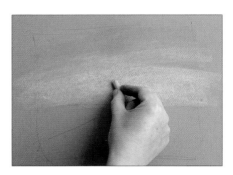

1 Draw in the horizon line as a dividing point with a pastel pencil. Block in the sky using French ultramarine, then apply a lighter tint closer to the horizon.

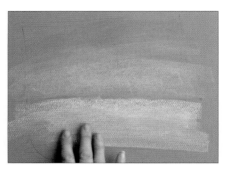

2 Add Winsor Lemon tint 3 below the horizon line and the darker Winsor lemon tint 4 in the foreground. Use your fingers to blend the yellows together, rubbing the pastel into the texture of the paper.

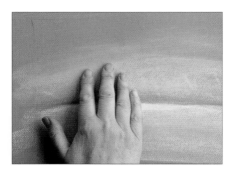

3 Before blending the sky, clean your hands to avoid transferring the colours.

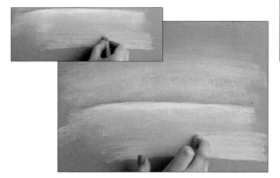

4 Add alizarin crimson tint 1 in the foreground and blend.

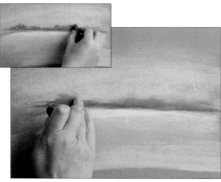

5 Block in the distant landscape forms on the horizon with Payne's gray and blend again.

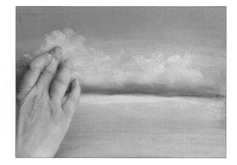

6 Use French ultramarine tint 1 for the clouds and blend in a circular motion to suggest cumulus form.

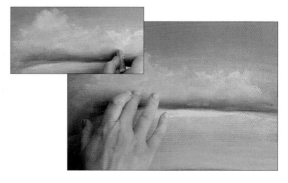

7 Introduce a little alizarin crimson to the clouds and gently blend in.

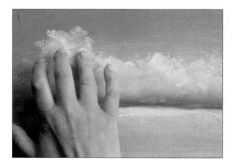

8 To develop the sense of light catching the cloud formation, lighten the tops of the clouds with titanium white and blend.

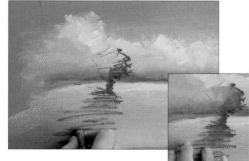

9 Put in the tree, which is the focal point, and the path leading to it, with Payne's gray and lightly blend.

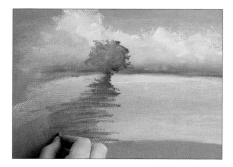

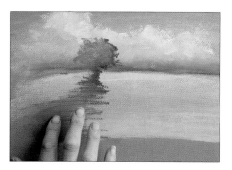

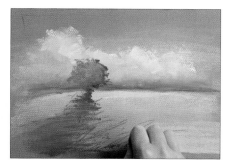

10 Apply green earth to the tree and path.

11 Blend the foreground but leave some texture in the tree.

12 Use the end of the pastel stick to put in some grasses with green earth, making sure the grass diminishes in size further away to create perspective.

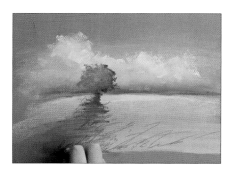

13 Add strokes of Payne's gray to the grass for interest.

14 Also apply a few lines suggesting grasses with Winsor lemon tint 3.

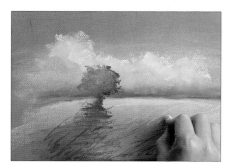

The finished scene, a simple, uncomplicated composition, perfect for experimenting with new techniques.

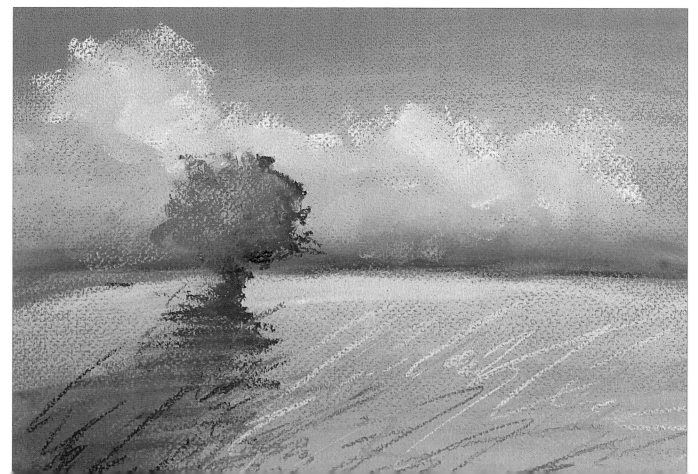

Using fixative

Pastel pictures sometimes require a certain amount of fixative to preserve the pastel and prevent smudging of the pigment. Generally speaking if you are going to work on paper and want to build up layers of pastel, you need to use fixative. You may want to preserve the wonderful marks you have made or avoid disturbing the colour already in place so that the next layer of colour will not physically mix with it. Unfortunately, spraying fixative too heavily will alter the intensity of the pastel and darken the paper. To avoid too much dulling and darkening of the colours, use fixative sparingly and only at intervals through the painting process, as I have done during this demonstration.

Always use in a well ventilated location near a window or preferably take it outside.

In this example a cover was placed over the left side of the paper while fixative was applied to show how much darker it makes the pigment and paper.

1 Draw in the outlines of the flowers with a white pastel pencil.

2 Block in the background colour lightly using the side of a gold ochre stick.

3 Block in the flowers in the same way with dark violet.

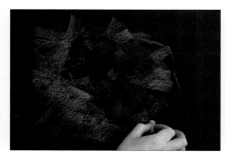

4 Lightly spray the painting with fixative from a distance of about 20–30cm (8–12in) from the paper. Here I have sprayed closer for the purposes of the photograph.

5 The fixative darkens the picture, so go over the gold ochre parts again with the same colour, to reinstate the original brightness. Spray again.

6 Work over the gold area again with Winsor yellow to lighten the colour and add texture.

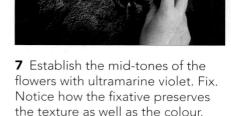

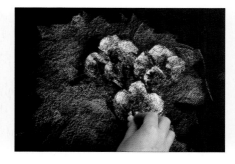

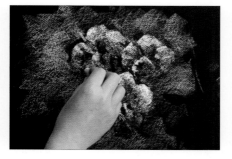

7 Establish the mid-tones of the flowers with ultramarine violet. Fix. Notice how the fixative preserves the texture as well as the colour.

8 Paint in the lightest tones of the orchids with titanium white.

9 Lighten the background with Winsor lemon where it has been darkened by the fixative.

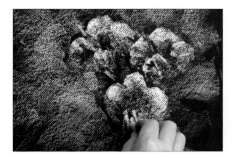 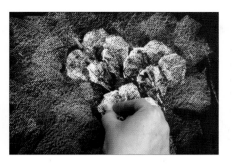 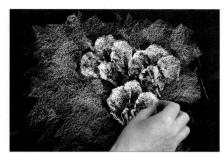

10 Paint in the yellow centre detail of the flowers with Winsor lemon. Fix.

11 Use white again to bring out the flowers, using the side and the end of the pastel stick to vary the marks you make.

12 Warm the white of the flowers with a little Winsor lemon to unify the painting.

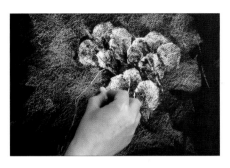

13 Suggest the stalk with gold ochre and then Winsor lemon.

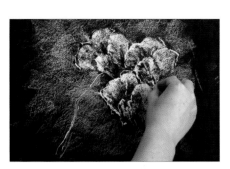

14 Add line work around the petals with gold ochre.

The finished painting.

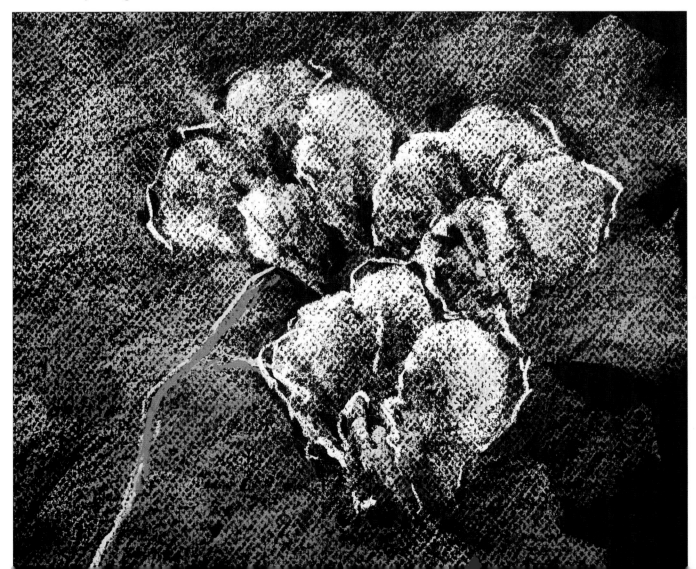

Storing, protecting and transporting

The nature of pastel means that they need careful handling both in stick form and as finished paintings. I believe that with a little extra care and attention, pastels can easily be stored and transported without risk of damage.

Storing pastel sticks

The fact that pastels have a powdery consistency means that dust forming is unavoidable. Storing a mixture of different colours together will create a grey or dirty dust, which can be accidentally transferred to your painting. My advice is to store them in boxes within their colour range: one for reds, one for blues etc. That way, any dust accumulation will be of the same hue and will not sully the colour of the pastels.

Trouser hanger

In my efforts to recycle, I have discovered a good use for a simple trouser hanger in my studio. I clip paintings in progress to it and hang them from a picture rail. Do not leave them for too long, as dust will accumulate on the surface of the painting.

Storing paintings

I tape a piece of glassine paper to each painting; it has an extremely slick/slippery texture that will not disturb the surface. I then layer the paintings in the drawers of my plan chest, several deep, where they are successfully stored with virtually no smudging. Good alternatives to glassine paper are tracing paper and even newspaper. Always take care that there is no lateral movement, as this would probably drag some of the pastel off the surface.

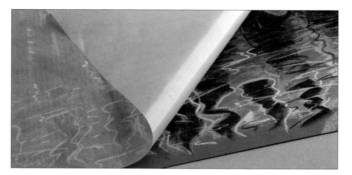

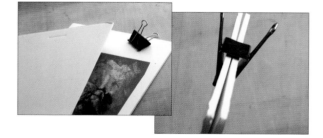

Foam core

Foam core has a slick surface, similar to that of glassine paper. It is sold in different sizes and comes in varying thicknesses but is also lightweight and sturdy. Attach a painting to a piece of foam core with tape and clip another piece of foam core to it as shown. These can be stacked for safe storage and are even strong enough for transporting.

Cardboard box

The boxes that my paper is delivered in are put to good use for transporting paintings. One picture clipped to each interior side of the box keeps them from touching and hence from smudging during transportation.

Framing

Pastel dust can accumulate on the lower section of the mount when the picture is framed. If you apply a spacer – another piece of mount card or foam core – to the back of the mount, this will create a gap between the picture and mount where the dust should fall. Remember to give your paintings a good shake to get rid of as many loose particles as possible before framing.

Tip
Take a few pastel sticks to the framer's with you in case a smudge occurs en route, for instant repairs.

Correcting mistakes

Correcting mistakes during a pastel painting can be very difficult and may not always be successful. I try my hardest to avoid making mistakes in the first place, but I must admit that a painting rarely materialises without some form of correction. Because my method of working is to build up very light layers of pigment, quite often another light layer over the top of the mistake is sufficient to disguise it. This can be done with or without the use of fixative, depending on the extent of the original mistake. If, however, you apply more pressure, resulting in a heavier layer of pigment, then there are other methods to put into practice. We all apply the pastel differently so in this section I have suggested several methods to try. Hopefully one will be successful for you.

> **Tip**
> Believe it or not, bread can be as effective as a putty eraser. Use very fresh bread that has a doughy consistency and mould it into a small ball, then use as you would a kneaded eraser.

If the pastel is not too heavy

If you want to completely remove the mistake and have only applied a light coating of pastel then this is a very good method to try.

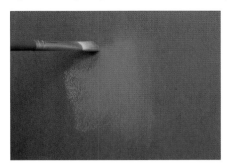

1 Brush off the excess pastel with a stiff brush.

2 Using the kneaded putty eraser, rub or dab to lift off the remaining pastel. Depending on the amount of pastel applied, you should be left with a near perfect surface to continue working on with no remnants of pastel.

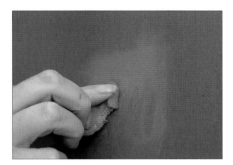

> **Tip**
> Sometimes brushing off the pigment is enough to return the surface to a satisfactory condition.

If the pastel is heavier

It is slightly more complicated if you have applied a lot more pastel and consequently have a thicker layer to remove. You can try scraping off with a sharp knife or scalpel, taking care not to damage the surface, but this technique is really only useful on smaller areas. For larger areas, you can try the following technique.

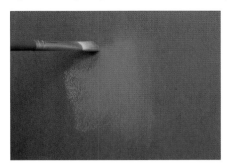

1 Brush off the excess pastel with a stiff brush.

2 Spray with fixative.

3 Choose a pastel to match the colour of your paper, and go over the fixed area with this. Fix again.

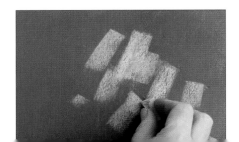

4 You should now be able to work over the area again.

Colour

A significant difference between pastel and other media is that colours cannot be pre-mixed and therefore must be mixed on the surface by either blending, layering or by arranging dots, lines or dashes next to each other for visual blending. The process of mixing colours this way can result in dull, less brilliant colour, which is in direct contrast to the vibrant characteristics pastels are famed for and is a common problem for the novice pastellist. To achieve successful results, knowledge of basic colour theory will help.

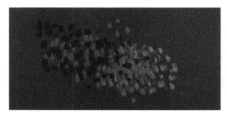

Colours put next to each other will visually blend together.

Primary, secondary and complementary colours

Red, blue and green are the primary colours that cannot be made by mixing any other colours together. Secondary colours are the result of mixing two primaries, so red + yellow = orange, yellow + blue = green, red + blue = violet and together these make up the standard colour wheel we all know.

Colours which are opposite on the colour wheel, such as red and green, are complementary or contrasting, which means that, when put next to each other, they are intensified and add dramatic impact (see below). Mixing two of these together will result in neutrals or greys.

Primary colours.

Primary and secondary colours.

Orange and blue mixed to make a neutral colour.

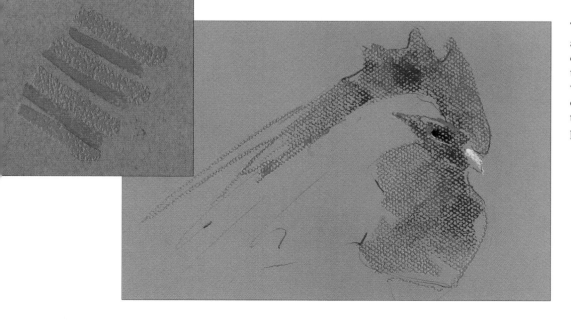

The same colour theory applies to paper. Red is complementary to green therefore the colours vibrate with intensity when applied over green paper or next to green pastel (see the hen picture, left).

Harmonising colours

Colours which are adjacent to each other on the colour wheel, for example red, orange and yellow, are harmonious and work well together to create an overall mellow mood to a painting.

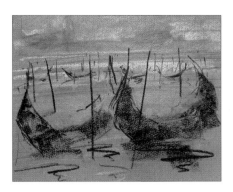

Gondolas
Colour harmony is achieved with an analogous palette of violet/blues and greens (left). The surface of mid-tone grey paper provides a neutral background, though this would work equally well on harmonising blue, violet or green paper. Once you have gained an understanding of harmonising colours, try adding a contrasting colour, as shown on the right.

Colour temperature

Colour has a relative cool or warm feel and is necessary for creating depth as cool colours generally recede and warm colours come forward. In the Sunflowers demonstration (pages 28–35), I have used the cool greens and blues in the background to create depth and warm colours for the flowers.

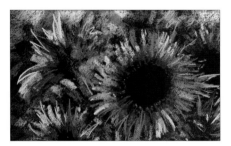

A detail from the
Sunflowers demonstration.

Pastel particles on the painting surface are the main culprits for causing dull, muddy colours as dust will inadvertently mix with the rest of the painting. Make sure you shake this away regularly. Keeping the painting surface upright also encourages the dust to fall away.

How to avoid muddy colours

It is a common complaint of newcomers to the medium that they get into a colour 'mess'. This I find is usually the result of incorporating too many colours into the painting. It is much easier to keep to a limited palette of harmonising colours, and as you progress, introduce a single contrasting colour (see the Gondalas picture on the right, above).

A few tips to help avoid muddy colours happening are:-

Keep pastels clean – dust can be transferred from the pastel to the painting.

If you cannot resist using lots of colour, use fixative regularly and as layers are added.

Keep to a harmonious palette.

Use a direct technique of applying the pastel and do not allow the marks to blend together.

Plan ahead with sketches and colour studies to ensure problems are resolved before the painting process.

Dark colours
Usually manufacturers produce a very good range of colour tints and shades, but quite often their darks are not strong enough. If your painting dictates that a darker tone is required, then try applying a layer of black to the area first, then overlay with the required colour.

Sketching and planning

There are several ways of gathering information to develop a painting: working from life, sketches and photographs are all part of the process. I like nothing better than setting up a still life and developing the work entirely from life in the comfort of my studio. However, I paint many different subjects in different situations, so this is not always possible.

Tuscan Olive Grove

During a recent visit to Tuscany I made this small colour study (right) using a selection of hard pastels in a pastel sketchbook. It is very basic but quickly captured vital information for me to work from. I was happy with the composition, the focal point of buildings in the top third of the composition and the olive trees in the near and middle distance.

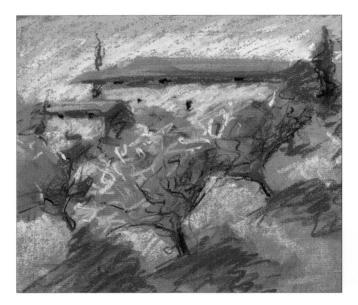

I always have cast-off pieces of paper from finished paintings which I use to experiment on, as I did here, to assure myself of the colour palette and to practise a range of marks. The step-by-step demonstration is on pages 38–47.

Sunflowers

I paint and draw sunflowers regularly through the season so have a good memory bank of information. Even so I still need to make sketches to decide on the composition and feelings I want to convey. For the Sunflowers demonstration on pages 28–35, I knew that I wanted to emulate the abundance of flowers, but I also needed to solve problems such as focal point and tonal arrangement.

The sketch on the left of the sketchbook is the result of several thumbnail sketches, which helped me decide on the tonal arrangement and the three flowers to become the dominant blooms. The sketch at the right was to help me understand the direction of the tilting flower heads.

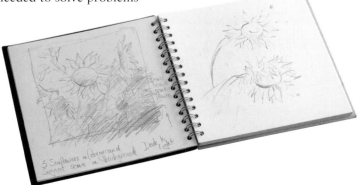

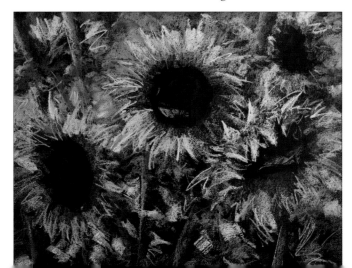

Colour studies like the one on the left answer lots of questions and provide the opportunity to practise techniques and marks to incorporate into the picture. Solving issues at this stage lessens the chance of mistakes at the painting stage.

Working from photographs: Mooring Poles in Venice

Carrying a camera is always useful for capturing those fleeting moments or for when there is not enough time to paint and sketch outdoors. Rarely do I replicate a photograph exactly, but make every attempt to change, eliminate and rearrange information to arrive at a pleasing composition.

By making a series of quick thumbnail sketches, you can make decisions on what to add and what to leave out. I decided to simplify the information in the photograph by taking out confusing and complicated sections such as the gondola in the foreground and boats in the distance. These will not be discarded but put to good use in another composition. It occurred to me that the poles in the foreground made an interesting feature and extended the possibilities of mark-making. They also lead the eye to the focal point of the door and blue and the white poles.

The colour study (right) has a sufficient body of information to complete the final painting.

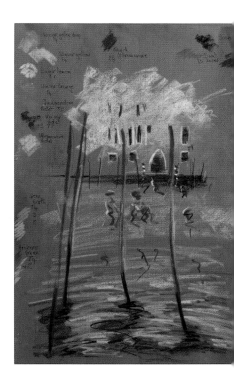

This final colour study (right) solved my colour questions and gave me the chance to practise the marks to be used. The step-by-step demonstration is on pages 50–61.

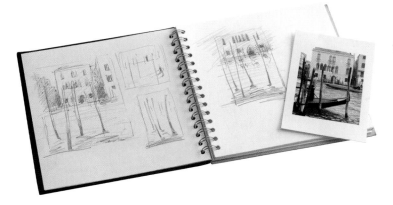

Composition

Consider the compositional arrangement and where to place the focal point while making thumbnail sketches. An effective guide is the rule of thirds, which establishes a position roughly one third in from two sides of the surface to place the focal point.

It is useful to divide the picture up with a series of lines and position the focal point on one of the crossing points (see above, right).

The same rule is applied to the painting Blue and White Flowers (right), with the small vase of flowers placed roughly one-third from the bottom and left side of the painting. The focal point is further enhanced with highlights to capture sunlight on the flowers.

A repetition of shapes creates a unifying foundation and a visual link between the various elements of the painting. The circles and curved marks have the added benefit of leading the eye around the composition (see the sketches below).

How I work

Whether on location or in my studio, I always stand to work, as shown in the photograph opposite. This gives me the freedom to move around and take a few steps back to judge and assess how the painting is progressing. It also gives me the opportunity to involve my whole arm in the painting process; I am convinced that getting my arm moving from the shoulder and elbow contributes to the expressive quality of my work.

Standing at an easel with work upright has the advantage of allowing any excess pastel dust to fall away from the painting rather than accumulating on the surface as it would if it was flat. This accumulation of dust would affect the purity of colours by mixing in with the existing pigment.

My easel is situated next to a full-length north-facing window, so it has perfect light conditions. However, on the occasional dull day or at night, I use daylight bulbs. Opening the window provides the crucial extra ventilation for the use of fixative, and next to my easel is a table where I place extra materials, a still life set-up or source material to work from.

It may seem like a waste, but I always work on full sheets of paper; even if the intended format is quite small. I prefer to have the option of the painting expanding rather than being restricted to an exact size. In fact, rarely does anything go to waste: the remaining unused edges are ideal for practising mark-making and trying out colour combinations, and any cast-off bits of paper are saved for experimenting.

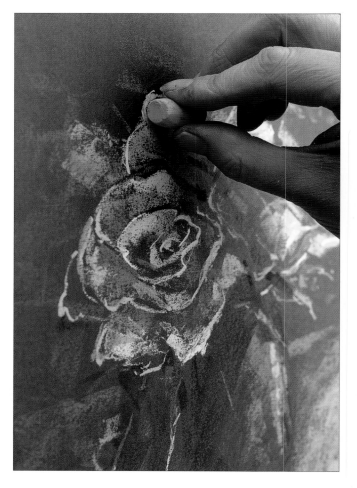

Working upright at the easel means that pastel dust falls away rather than accumulating on the painting.

Plastic trays make a perfect palette. I begin with a basic palette and add pastels as the painting progresses.

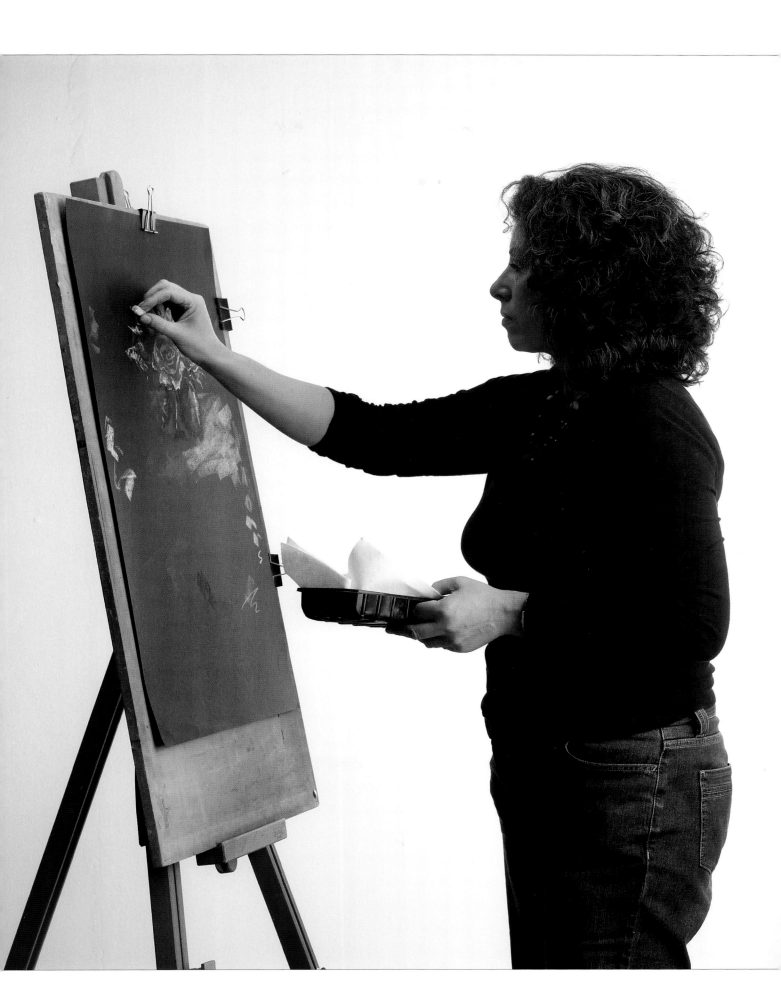

Demonstrations

The three demonstrations all follow my painting process from initial drawing to lively painting techniques. Each one has been painted on a different surface, either sandpaper or textured paper, and on a different colour, but they are all dark toned as I have a particular fondness for the vibrancy that the dark colours create. All are painted using Winsor & Newton pastels from their assorted set of seventy-two soft pastels.

Each picture begins with a line drawing, without concern for detail, and with the subject reduced down to basic shapes, for example a series of squares and rectangles are the basis for an architectural subject or, as in the Sunflowers demonstration, circles and ovals. Any fine renderings at this stage would hamper the painting process and would be obscured by successive layers of pastel.

With the shapes in place, the next stage is to block in, with the primary focus being to develop shape, form, tone, texture and colour with successive pastel layers of expressive marks. This may appear to be a loose and spontaneous stage of the process but it is actually a careful and considered period of continual judging and assessment of the composition. I never develop any one particular area at this stage, preferring to work all over the paper at the same time, gently encouraging the image to emerge from the paper.

Once all the elements of shape, form and tone have been established, the foundation is in place upon which to add the detail and character of the subject. Whereas I was earlier quite cautious, I now have the freedom to use lively and gestural marks to bring the painting to life.

This painting style is very bold and expressive and requires a certain amount of confidence to achieve results. I recommend practising some of the techniques explained earlier in the book, which will give you the required grounding and hopefully the confidence to have a go yourself.

Ginger Jar and Amaryllis
39 x 34cm (15³/₈ x 13³/₈in)

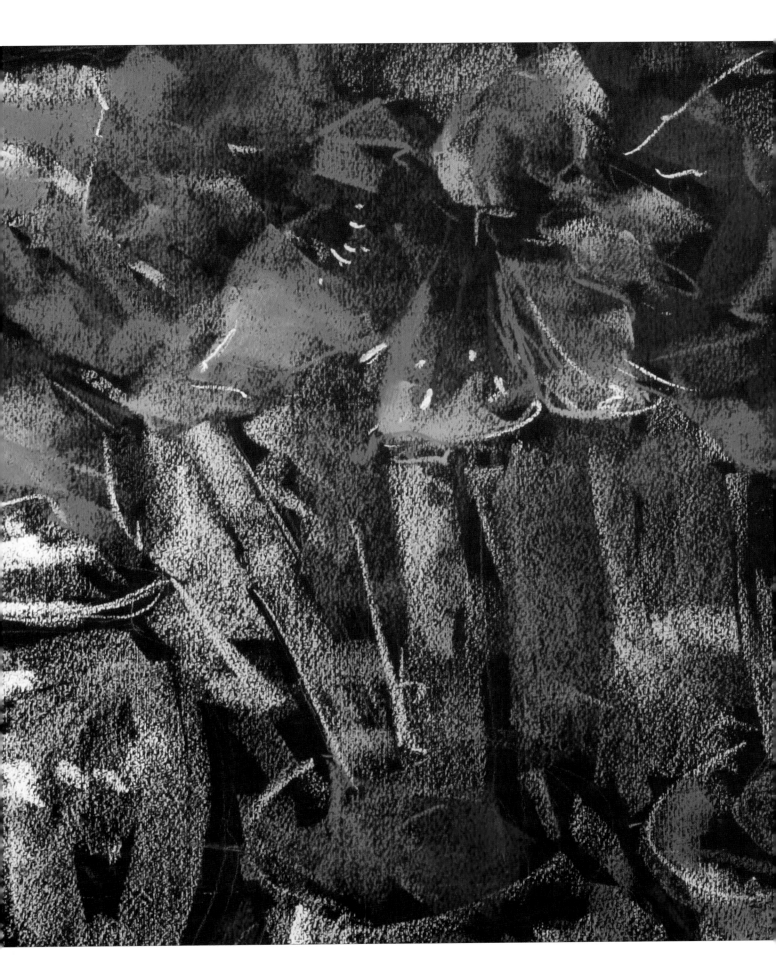

Sunflowers

A fabulous border of sunflowers in my neighbour's garden inspired this painting – I could not resist the huge yellow blooms dancing about in the sunshine. Large flowers such as these are particularly suited to the bold application of pastel and the vibrancy of colour. I chose black paper to leave exposed for the centres of the sunflowers, to establish the darkest tone, and the resulting contrasts added impact and drama.

1 Use a pastel pencil to draw in the shapes of the flower heads. I have used an orange colour but that is not crucial, it just needs to be visible. Alter the perspective of the circles so that the directions vary.

2 Begin to block in the darker tones of the petals with burnt sienna tint 4, using the side of the pastel.

3 Suggest the darker values in the foliage with French ultramarine tint 4. Do not cover all the paper – leave some of the black exposed and enjoy the process of painting.

28

4 Add Payne's gray tint 4 to the blue of the foliage for some of the dense shadow areas. Even at this stage, take a step back and make decisions on the composition – ask yourself if the arrangement of colours, shapes and textures is balanced. Apply the pastel lightly so that any mistakes can simply be covered over with further application of pastel and absorbed into the picture.

5 Use oxide of chromium tint 4 to suggest the green of the leaves. Continue working with a very light application of the pastel.

6 Use burnt sienna to overlay the previous layers of petals. The marks should follow the direction in which the petals grow. Leave paper showing for the centres.

7 Overlay the dark blue areas with French ultramarine tint 4, making sure that you manipulate the pastel stick to create movement in the background leaves. Texture, colours and movement should cover the majority of the surface at this stage with only the seed heads exposed and some of the black paper showing through the light layers. Now that the initial blocking in is complete, fix it with a spray of fixative so that the texture and colour will remain intact as new layers are laid on top.

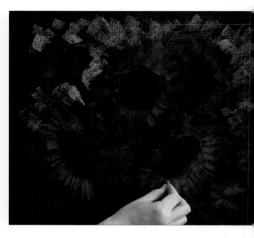

9 Rework the burnt sienna of the petals in the three main flowers, as they will have been darkened by the fixative. This should move the three focal point flowers into the foreground.

8 Use cobalt blue hue tint 2 to block in the light areas of the sky in the background, working in the negative space of the flowers.

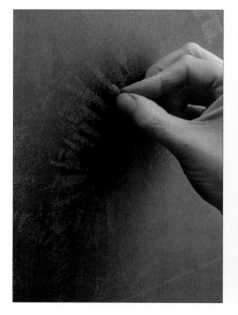

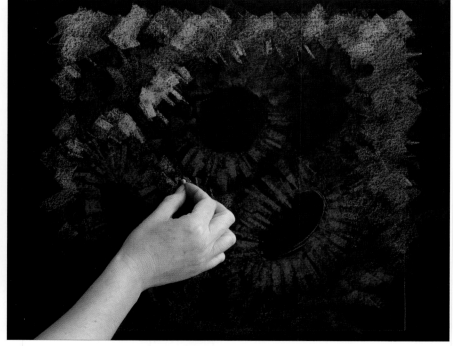

10 Make sure some of the petal marks break up the dark area of the flower centres.

11 Using oxide of chromium, continue to build up broad marks and texture in the foliage and in the negative space around the petals, then add more cobalt blue hue. This in effect is a glazing process as the continual overlaying will eventually create rich values and the many layers will enhance the textures. Fix.

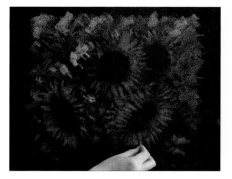

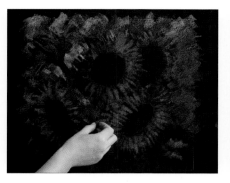

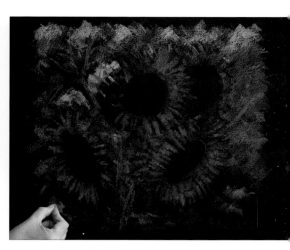

12 Add Winsor orange tint 4 where the light catches the petals. This will begin to create form.

13 Using French ultramarine tint 4, work over the middle ground and background to enrich the colour and texture. Add Payne's gray to neutralise this a little.

14 Use French ultramarine tint 1 to intensify and lighten the sky area near to the top of the painting. Change to oxide of chromium to begin defining leaf and stalk shapes, but make sure they are more loosely defined than the sunflowers so they recede into the middle and background. Add more Winsor orange to balance the greens and blues. Fix.

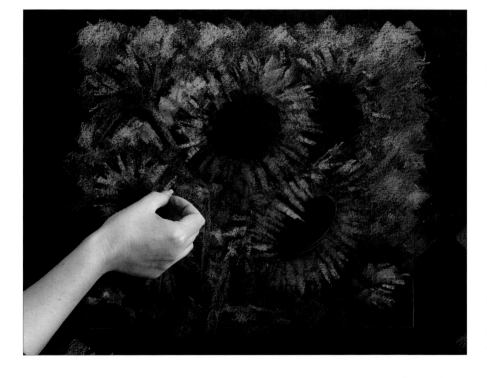

15 Apply some Winsor yellow deep tint 4, which is the middle value yellow, to the edges of the petals. Also introduce some of this colour into the background for colour harmony.

16 Take some time to assess how your painting is evolving – stand back and consider balance of tone, colour and marks. Do this regularly throughout. Add more French ultramarine tint 1 to intensify the light towards the top of the painting, suggesting a gradation of tonal value from light at the top to dark towards the lower section of the painting.

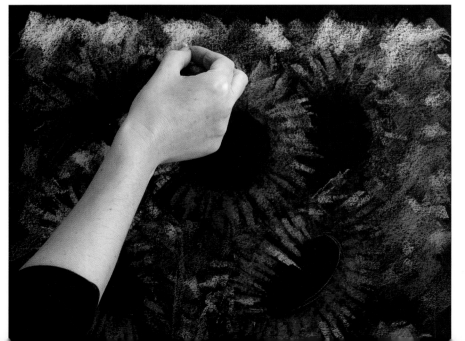

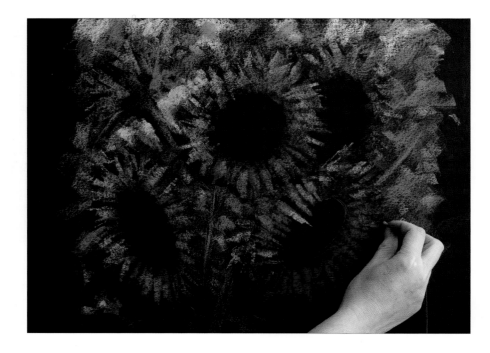

17 Attention is being drawn to the light blue area of the top of the painting. Add mid-toned Winsor orange and oxide of chromium to readjust the balance. Fix the painting.

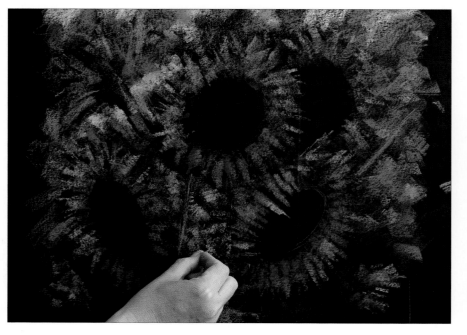

18 Even though there needs to be an obvious difference between the mark-making in the distance and foreground, to suggest depth, they still need to be visually connected. To achieve this, continue to add the colours of the flowers to the foliage as well: Winsor yellow deep, Winsor orange and oxide of chromium.

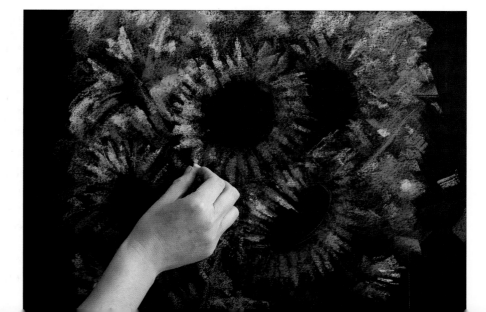

19 As the painting progresses begin to use more pressure on the pastel. The slightly heavier application deposits more pastel to the surface and is therefore brighter. Use Winsor yellow deep to add some highlights to the foliage and petals.

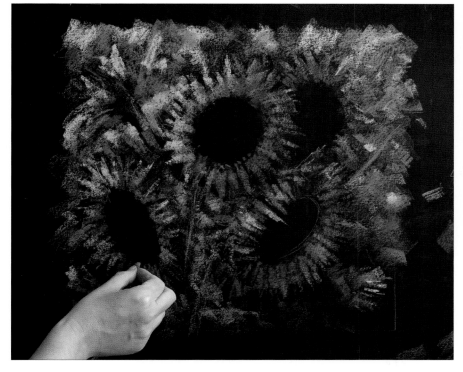

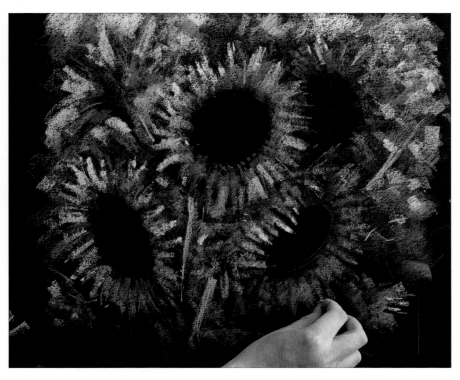

20 Apply dots and dashes with burnt sienna to create the effect of seeds in the centres of the flowers. Add more Winsor orange to some of the petals. Fix.

21 Now begin to add the lightest lights to bring the painting to life. Add Winsor lemon tint 1 to the petals and some of the stalks.

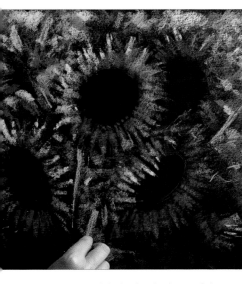

22 Re-establish the lightest blue with French ultramarine tint 1 at the top of the painting. Using permanent sap green tint 3, drag the pastel to give the effect of the stalks.

23 Add more detail with strokes of pastel in the petals with yellow ochre tint 4 and Winsor orange.

24 Use oxide of chromium around the outside of the petals, and add leaves over the dark tone area of the flower in the right middle distance. Fix.

25 Continue to add a variety of marks and strokes using the end of the burnt sienna pastel stick. Create some energetic, gestural strokes within the petals.

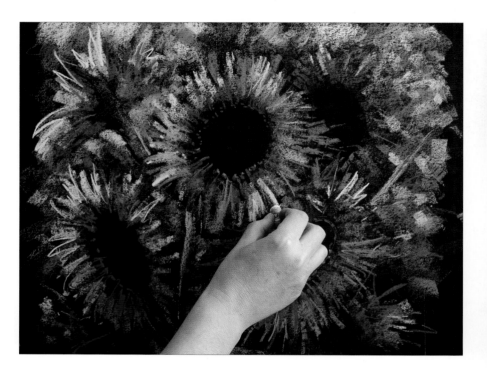

26 Add more marks to the petals with Winsor orange and Winsor lemon.

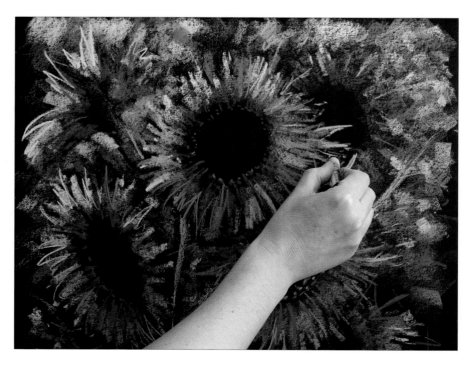

27 Finally, add marks using the end of the permanent sap green pastel to highlight the foliage.

The finished painting. To unify the painting, I added more French ultramarine tint 4 at the final stage. You will notice that I did not use any fixative on the finished painting, as this can cause irreversible darkening of the pigment and paper, with some of the lighter tints being lost completely.

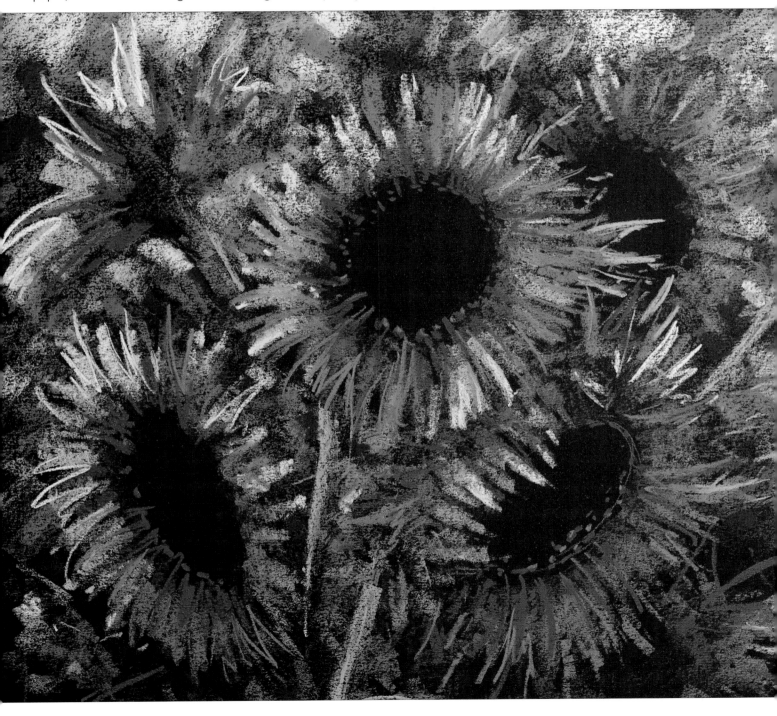

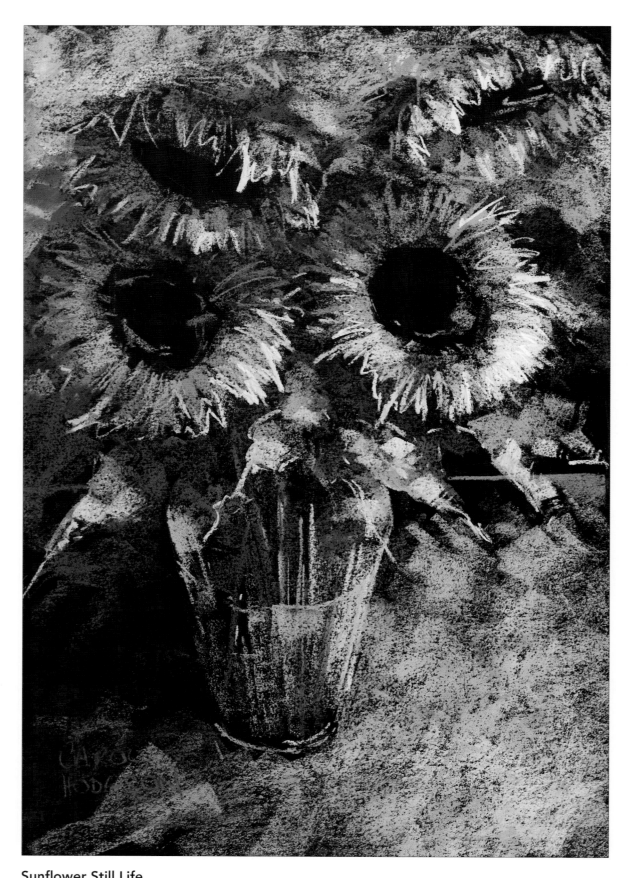

Sunflower Still Life

41 x 19cm (16¹/₈ x 7¹/₂in)

The black textured paper gives plenty of tooth to grasp the pigment.
I applied the pastel with a firmer pressure, resulting in stronger colours.

Opposite
A very painterly feel was achieved
in this sketch with broad blocks of
colour and energetic strokes.

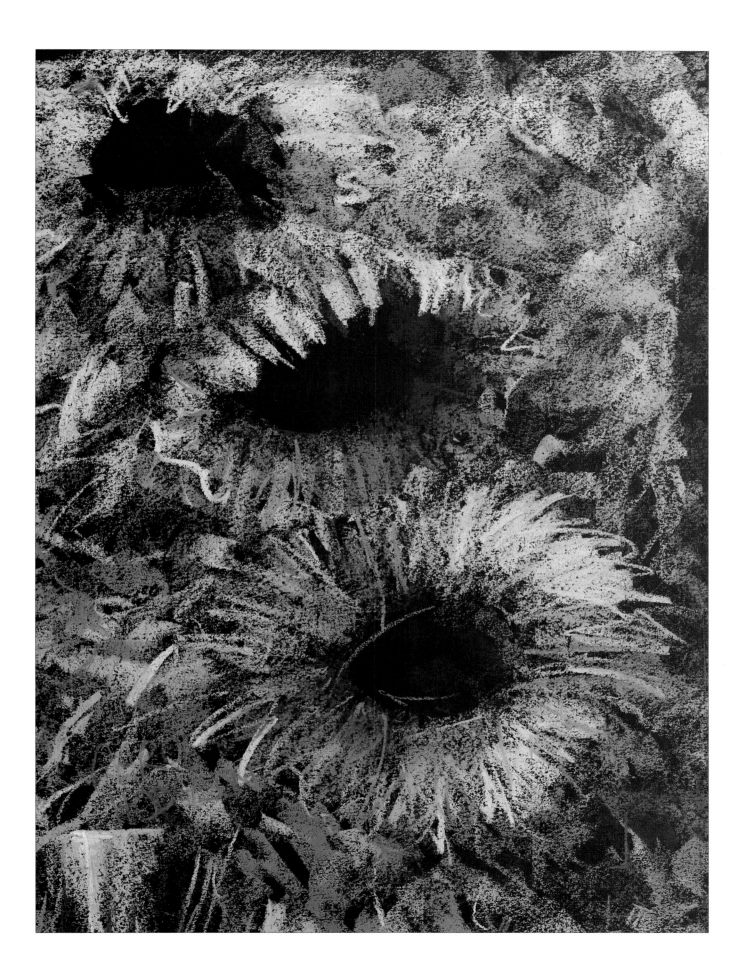

Tuscan Olive Grove

The Italian countryside offers fantastic painting possibilities, from vine-covered hillsides to pretty villages and landscape vistas. For this demonstration, I chose an old building on an elevated position above a hillside of olive trees.

I chose warm green paper, which harmonises with the earth colours, and divided the composition into thirds with the focal point of the building in the top third and the remaining two-thirds for the trees. The trees lead the eye around the painting and eventually to the focal point, and their reducing proportions create the illusion of distance.

1 Draw in the geometric shapes of the buildings towards the top third of the paper with the pastel pencil. Draw the rounded shapes of the trees, making sure the trees in the foreground are larger than those in the middle and far distance.

2 Use cobalt blue hue tint 2 to block in the sky, using the side of the pastel with light and lively marks.

3 Working in the negative space around the trees, block in the area of land with burnt sienna tint 4. This sets the darkest tone of this space. Leave the tree shapes, trunks and shadow area unpainted.

4 Apply gold ochre tint 4 to the middle distance. Introduce some of this colour into the first application of burnt sienna so they merge, creating a gradual change of tone.

5 Still using gold ochre, block in the walls of the building.

6 Using burnt sienna, gently drag the pastel in the direction of the roof slope and repeat for the outbuilding. Directional marks enhance shapes and add interest.

7 With the same colour block in the shaded sides of the buildings.

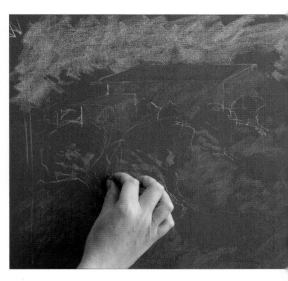

8 Use gold ochre to make small marks within the trees to suggest gaps in the foliage.

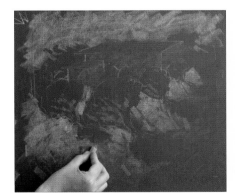

9 Avoiding the trees, paint the middle ground with raw sienna tint 5. Notice the arrows in the top left hand corner – you can use these as a guide to remind you of the direction of the sun and the resulting cast shadows.

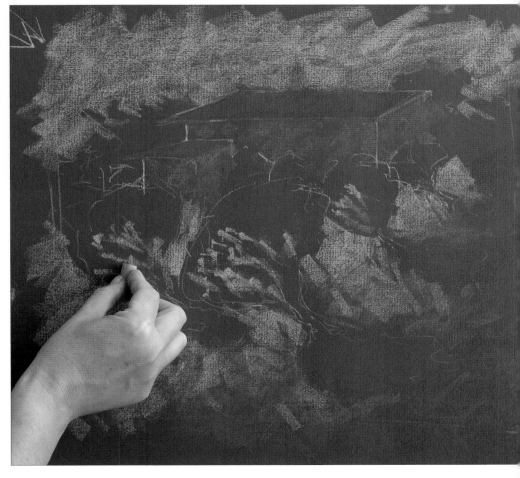

10 Lighten the breaks in the foliage of the trees with raw sienna.

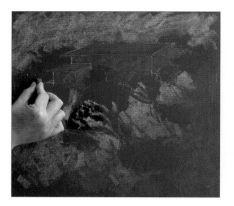

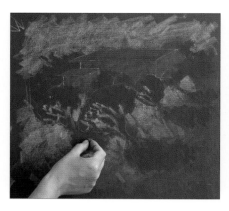

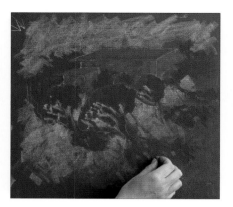

11 Block in the darkest tones of the background trees with Payne's gray tint 5.

12 Continue blocking in the olive trees and the shadow areas under the trees with Payne's gray.

13 Paint some gold ochre into the shadow areas to suggest filtering sunlight.

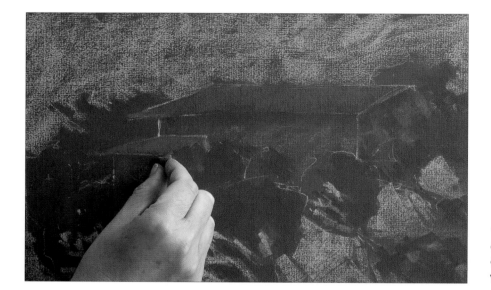

14 Paint shadows under the eaves of the roof and on the sides of the building and outbuilding with Payne's gray.

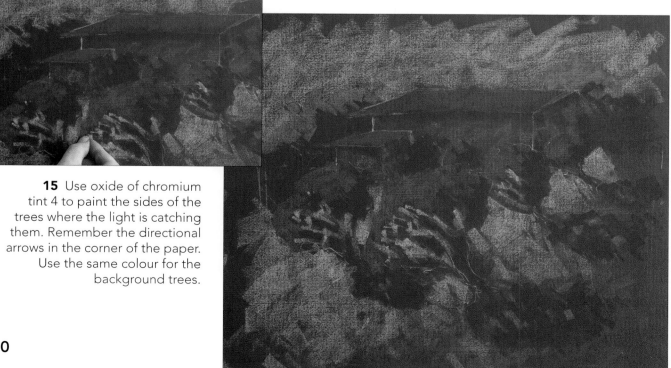

15 Use oxide of chromium tint 4 to paint the sides of the trees where the light is catching them. Remember the directional arrows in the corner of the paper. Use the same colour for the background trees.

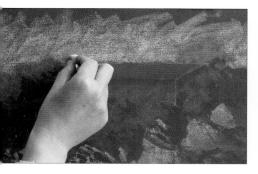

16 Apply French ultramarine tint 1 to lighten the sky nearer to the horizon.

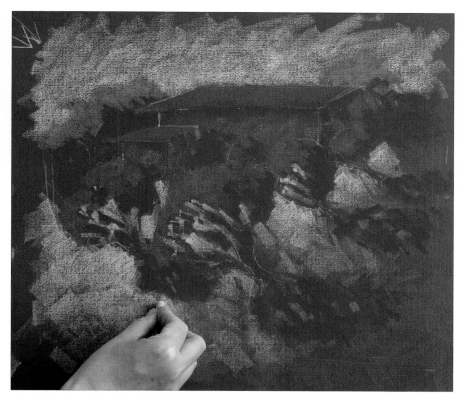

17 Lighten the middle distance and the negative space around the trees with yellow ochre tint 1. Now that the paper is completely covered in colour and expressive marks, fix.

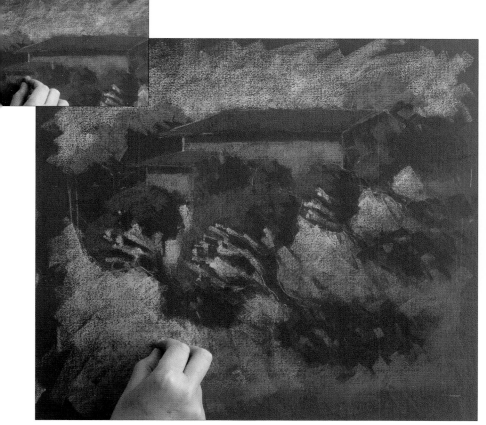

18 Add warmth in the sunlit walls with Winsor orange tint 4. Introduce the same colour into the foreground and middle distance.

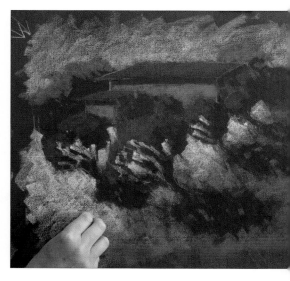

19 Use yellow ochre to enhance the light in the mid-section of the painting. Notice how the paper texture and colour is consistently showing through. This will unify the colours and leave enough tooth for the following layers to adhere to.

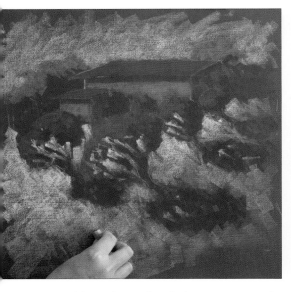

20 Lighten the dark tone areas of the foreground with raw sienna , allowing some of the first layers to show through.

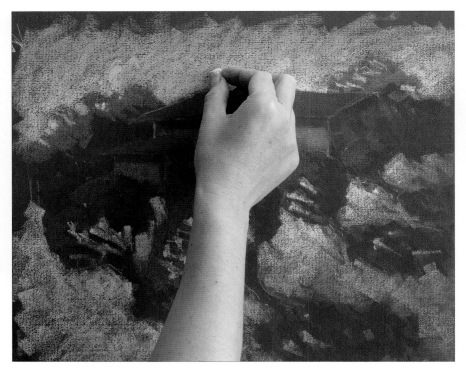

21 To balance the lighter tints you have just added, apply more cobalt blue hue and French ultramarine to the sky. Put some into the background trees to suggest breaks in the foliage. This also creates an interesting pattern to break up the large sky area.

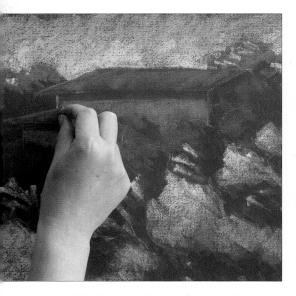

22 Lighten the roof with gold ochre, making sure the marks move in the direction of the roof's slope.

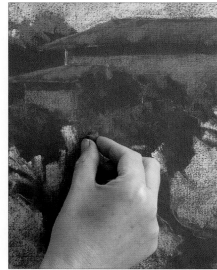

23 Add a little more Payne's gray into the foliage to increase the shadow intensity.

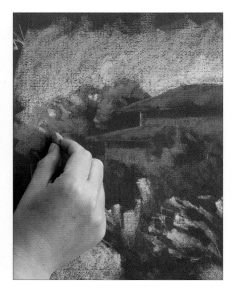

24 Apply permanent sap green tint 4 to the distant trees. Think about twisting and turning your wrist to make an interesting variety of marks.

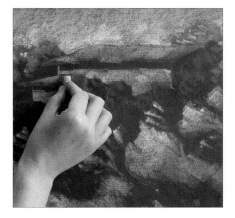

25 Further lighten the buildings and roofs with raw sienna.

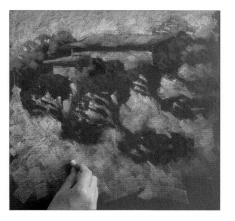

26 Work over the foreground with the same colour.

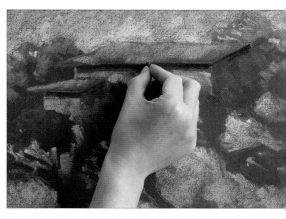

27 Paint the shadows under the eaves with black.

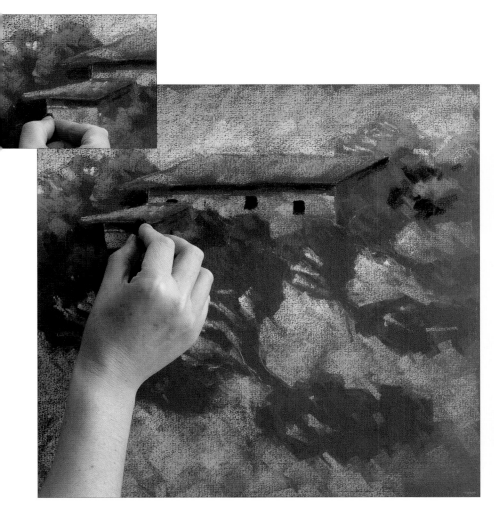

28 Paint the darkest tones of the background foliage with black and also the area to the left of the smaller building. The contrast of dark and light will give definition to the building's edge. Now fix the buildings. When the fixative has dried, paint the windows with black.

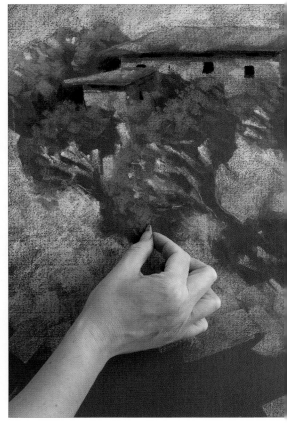

29 Use oxide of chromium to strengthen the lights in the sunlit sides of the trees.

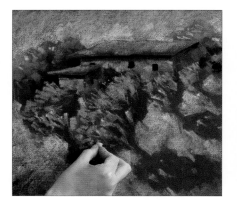

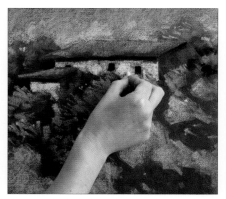

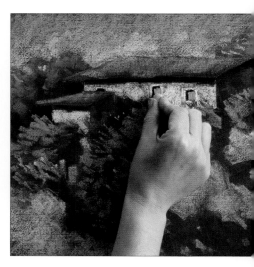

30 Add cobalt blue hue to the olive tree foliage.

31 Lightly apply yellow ochre to the building to create the impression of sunlight while allowing the underlying textures to show through.

32 Use the end of the French ultramarine pastel to paint the detail around the windows, then use cobalt blue hue for the shutters over the black. Leave black showing at the top and left-hand sides.

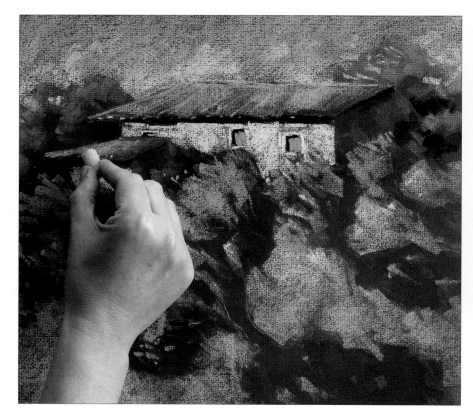

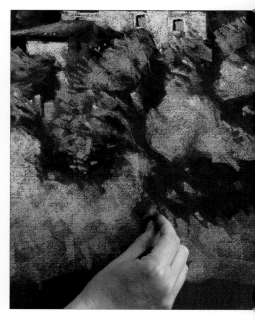

33 To increase the feeling of warmth, apply Winsor yellow deep tint 4 to the roof, using broad, flat marks. Then apply some contrasting marks using the end of the stick.

34 An assessment of the painting made me decide that the shadow area of the tree in the bottom right was too defined, so I introduced broken shadows to the surrounding land with Payne's gray.

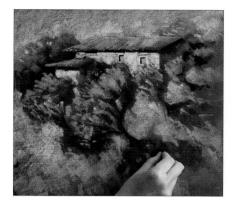

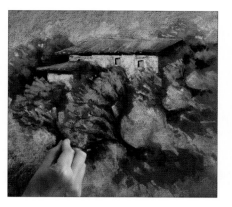

35 Use black to define the trunks and branches of the olive trees and add darker patches to the shadows.

36 Use the end of the black pastel to suggest branches running through the olive foliage.

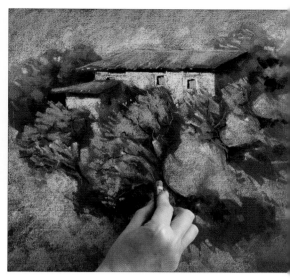

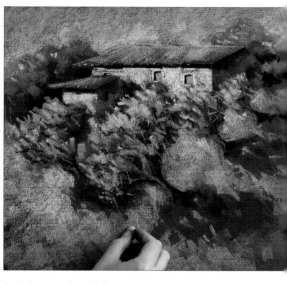

37 Apply burnt umber tint 3 to the trunks using the end of the pastel and add branches in the foliage.

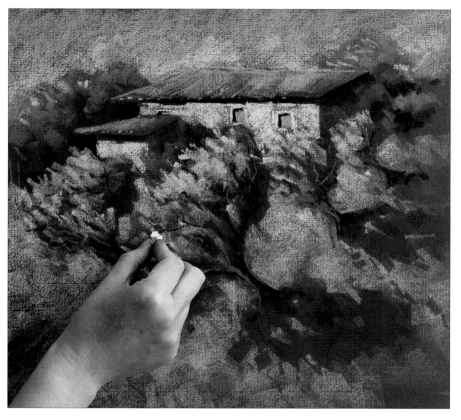

39 Add cobalt blue hue to the foliage and paint a little on the ground to balance the picture.

38 Add French ultramarine to the foliage for texture and light catching the leaves. Also introduce a few light strokes of the same colour to the area surrounding the trees. This will add interest and contrast to the warm mass of colour.

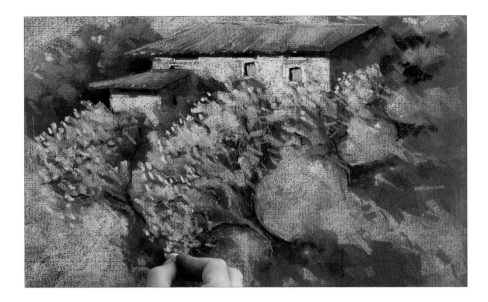

40 Now that everything is established, add more texture and variety of strokes and marks into the trees with a combination of French ultramarine and cobalt blue hue.

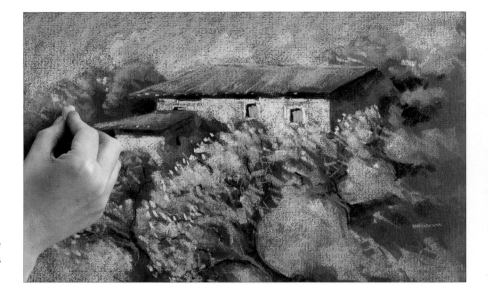

41 For more interest in the background trees, add a few dots and dashes of Winsor yellow deep.

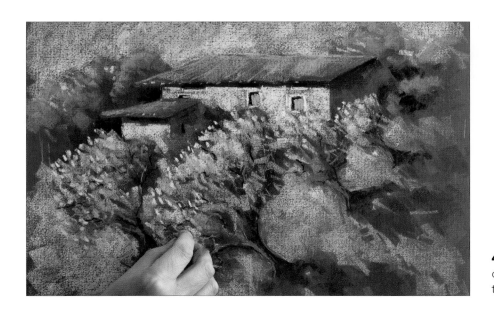

42 Pick out some of the branches of the olive trees and highlight them with Winsor orange.

The finished painting.

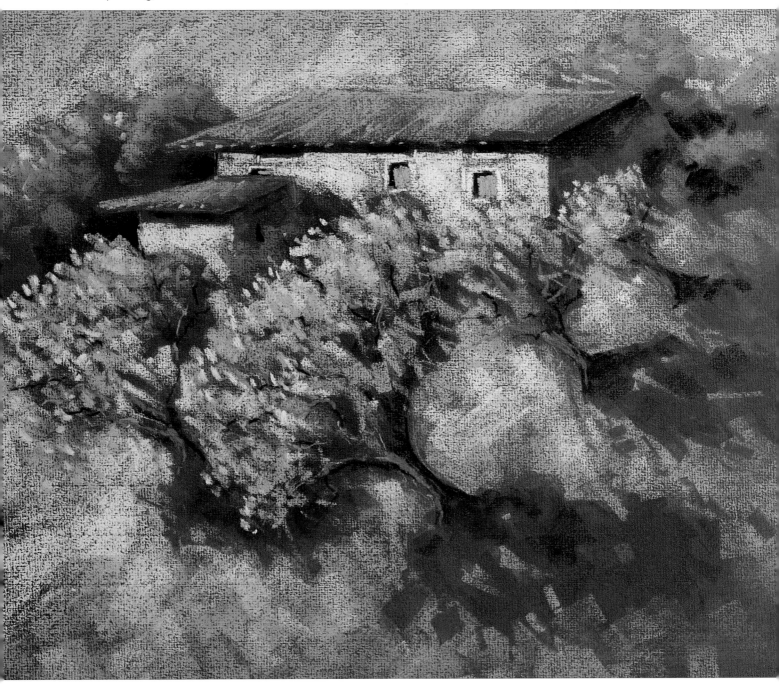

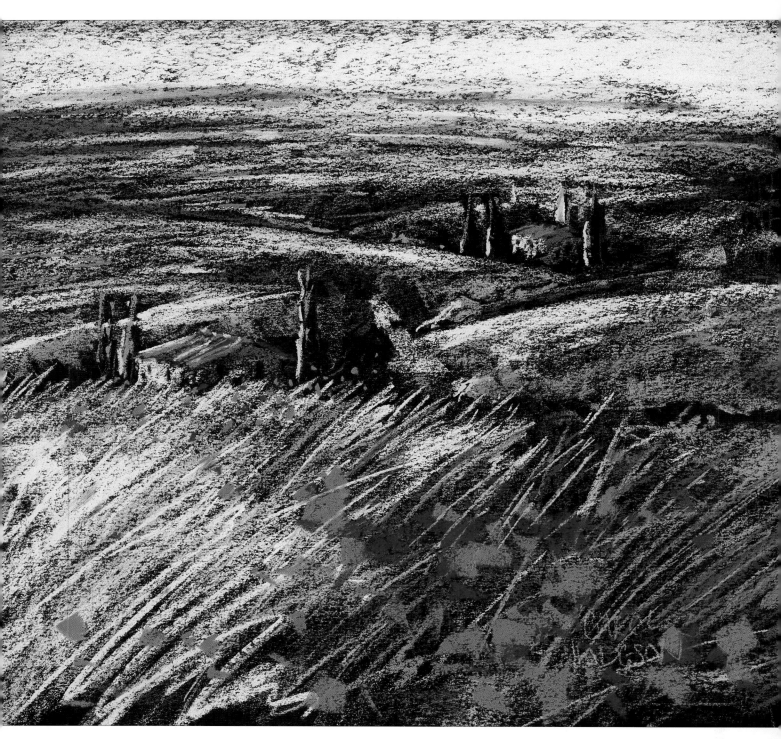

Tuscan Poppies
34 x 32cm (13³/₈ x 12⁵/₈in)

In this painting the reducing size of the poppies creates the illusion
of depth, as do the buildings and fields.

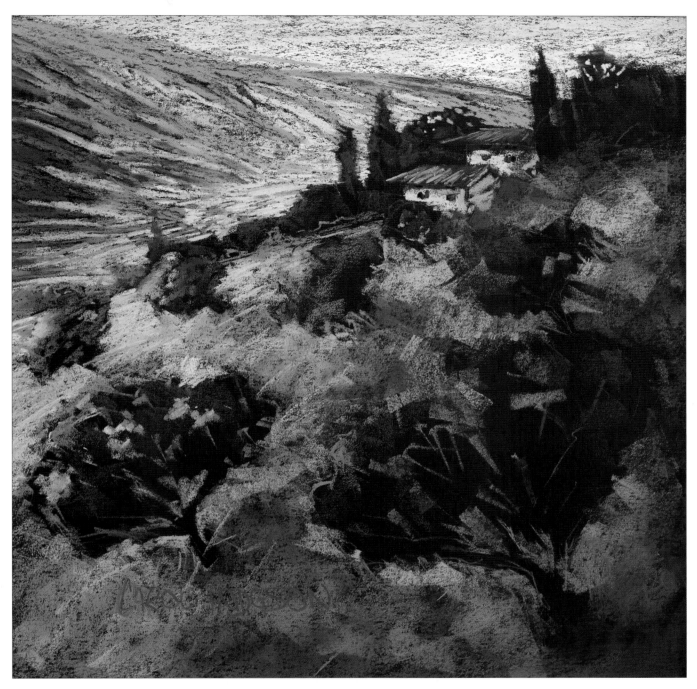

Sunlight on the Val d'Arno
39 x 39cm (15³/₈ x 15³/₈in)

This is similar in compositional arrangement to Tuscan Olive Grove in that there are trees and energetic marks in the foreground which lead the eye to the focal point of the buildings. A sense of perspective is created by the lighter hues in the distant valley and with marks of diminishing size.

Mooring Poles in Venice

Venice and its colour and architectural detail give me the perfect opportunity to exploit the wonderful characteristics of pastel with expressive, bold mark making. To be sure of capturing the bold marks, I chose a sanded surface, which has enough tooth and texture to grasp the pigment. The added benefit of this surface is that it can take many layers of pastel without the use of fixative, which would affect the vibrant colours. The vertical composition was dictated by the tall foreground poles, which ultimately influenced the portrait format. To counterbalance the strong verticals, a combination of horizontal gestural strokes were added. To complete the variety of marks, shorter marks were used for the architectural detail.

You will need

Yellow pastel pencil
Dark grey sandpaper
Pastels:
violet dioxazine tint 4
quinacridone violet tint 2
Winsor orange tint 4
Winsor yellow deep tint 4
Winsor yellow tint 4
Winsor lemon tint 1
oxide of chromium tint 4
cobalt blue hue tint 2
raw sienna tint 3
black
oxide of chromium tint 2
titanium white
Davy's gray tint 4
burnt umber tint 3
raw umber tint 5
cobalt blue tint 4
Kitchen paper

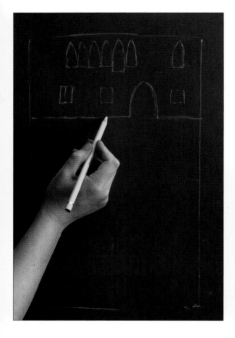

1 Draw in the main shapes of the composition with yellow pastel pencil. Avoid all detail and do not put in the poles as they will be added later.

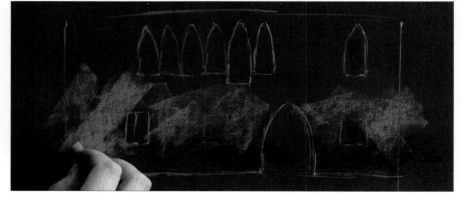

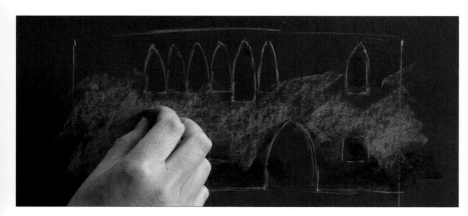

2 Using violet dioxazine tint 4, begin to block in the area just above the water line with the side of the pastel, then add quinacridone violet tint 2 to the middle of the building. It is fine to let the pastel run over the drawing as it will show through the initial light layers.

3 Using the flat edge of Winsor orange tint 4, apply broad marks to the middle of the building.

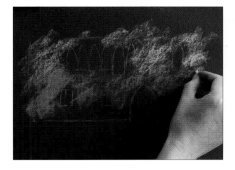

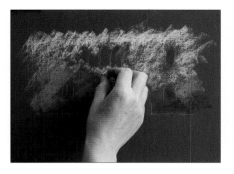

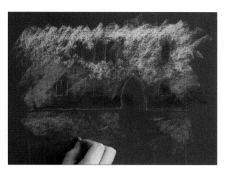

4 Add Winsor yellow deep tint 4 at the top of the building. Make sure the colours overlap each other.

5 Take the slightly lighter Winsor yellow tint 4 and paint over the top area with diagonal crisscrossing marks. Bring this down into the other colours a little.

6 Begin to replicate the building colours in the water with quinacridone violet, then Winsor orange.

7 Bring the quinacridone violet up into the yellow at the top of the buildings.

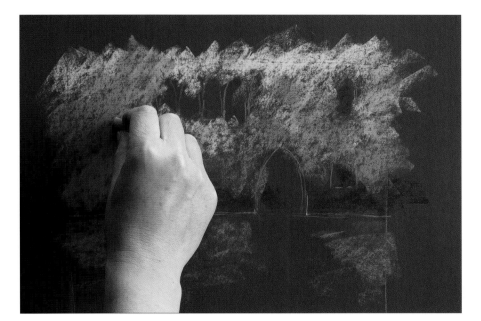

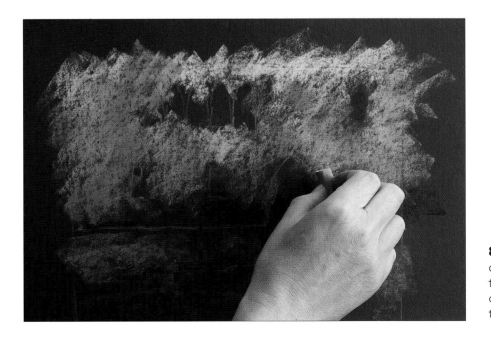

8 To make sure that obvious bands of colour do not develop, continue to introduce colours into each other. Add Winsor yellow deep into the quinacridone violet.

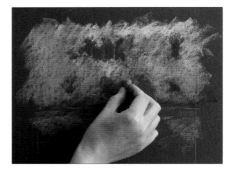

9 Reintroduce quinacridone violet into the darker violet dioxazine at the bottom of the buildings.

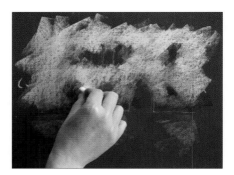

10 Knock back this area with Winsor lemon tint 1 so that the colours show through.

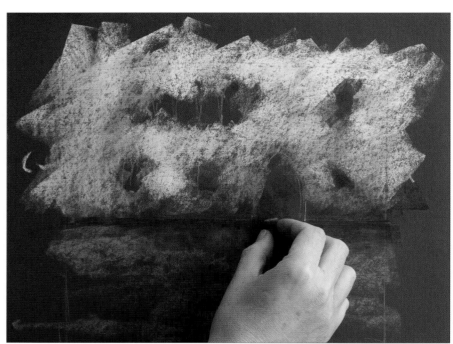

11 Reinforce the darks at the base of the building with violet dioxazine then repeat the colour in the water with marks of a more horizontal direction and a fluid feel.

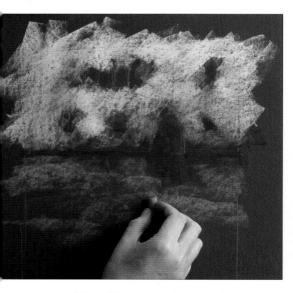

12 Add quinacridone violet in the water.

13 Add Winsor yellow deep to the water using the same horizontal but slightly curving strokes.

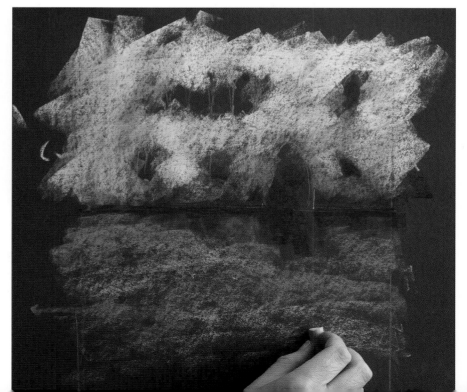

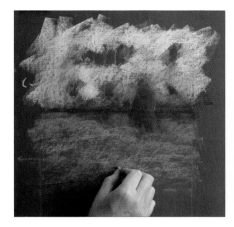

14 Add Winsor orange to warm the water area.

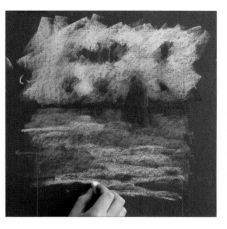

15 Paint over the top of the water colours with Winsor lemon using horizontal strokes to suggest fluid movement.

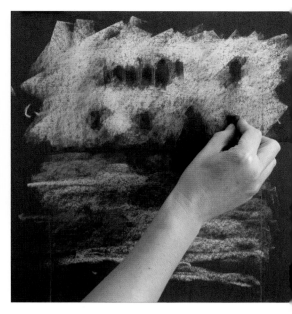

16 Paint violet dioxazine in the windows using short, block-like marks.

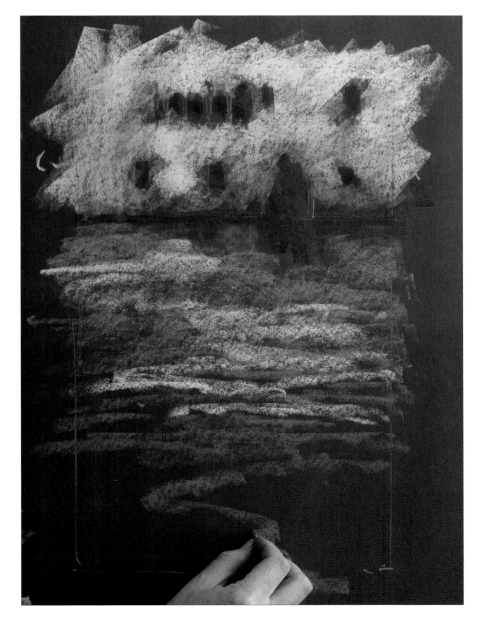

17 Paint the foreground water with oxide of chromium tint 4, using sweeping horizontal marks but leaving a large proportion of the paper exposed, as further layers will be built up as the painting progresses. Add some of the green into the reflections of the building.

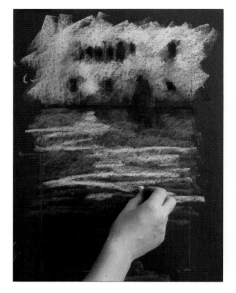

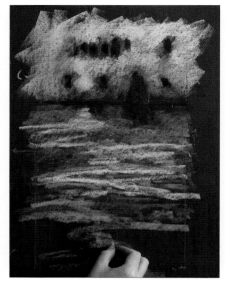

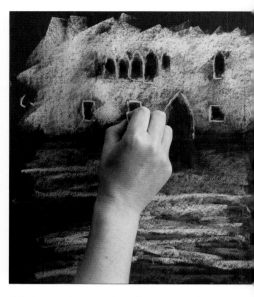

18 Add Winsor lemon to lighten the water.

19 Paint reflected sky colour in the water using cobalt blue hue tint 2.

20 Paint the window frames with raw sienna tint 3. Use the end of the stick and vary the pressure you use to create uneven lines.

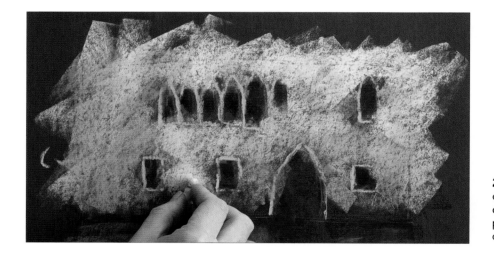

21 To unify all the previous layers of colour, apply very light sweeps of raw sienna using the side of the pastel. Make sure that the previous colour and texture show through.

22 Add Winsor lemon to the top of the buildings to suggest a sense of sunlight and with the same colour, highlight the tops of the window frames using the end of the pastel.

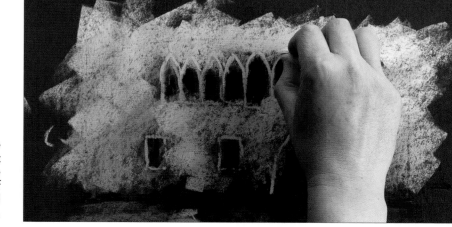

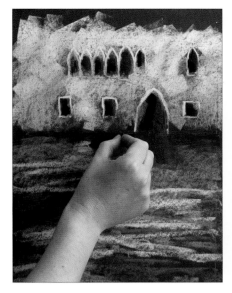

23 Use black to create depth on the insides of the door and windows, and to the water's edge. Do not completely cover the quinacridone violet applied earlier.

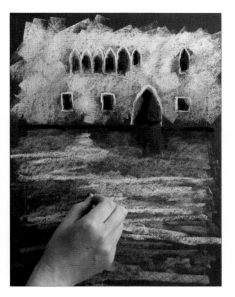

24 Strengthen the horizontal marks in the water with Winsor yellow deep.

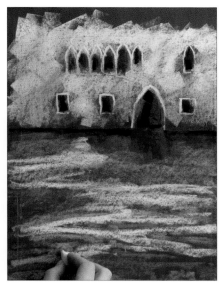

25 Add more Winsor lemon in the same way.

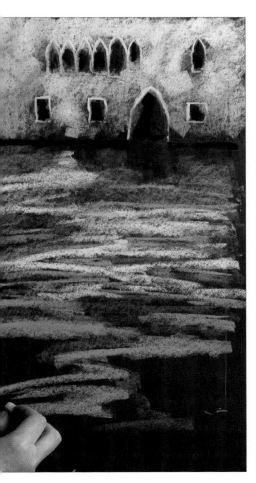

26 Strengthen the blue in the foreground water by adding more cobalt blue hue.

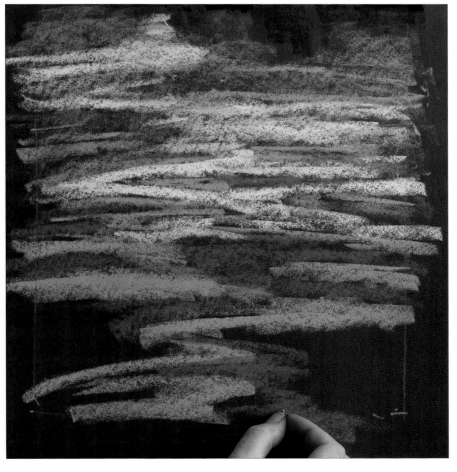

27 Reinforce the green in the water with more oxide of chromium.

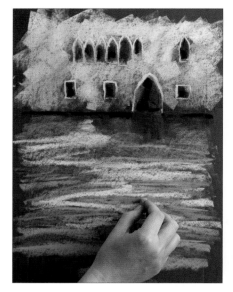

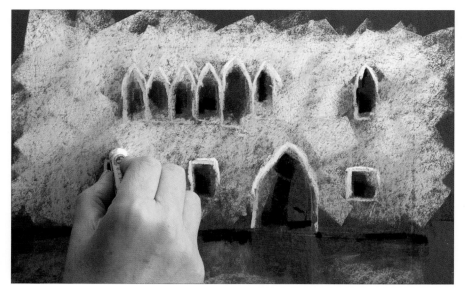

28 Still making fluid, horizontal strokes, apply oxide of chromium tint 2 to the water closer to the building.

29 Take advantage of the opportunity to vary the mark making with architectural detail. Use titanium white to add highlights to the arch of the door and tops of the windows.

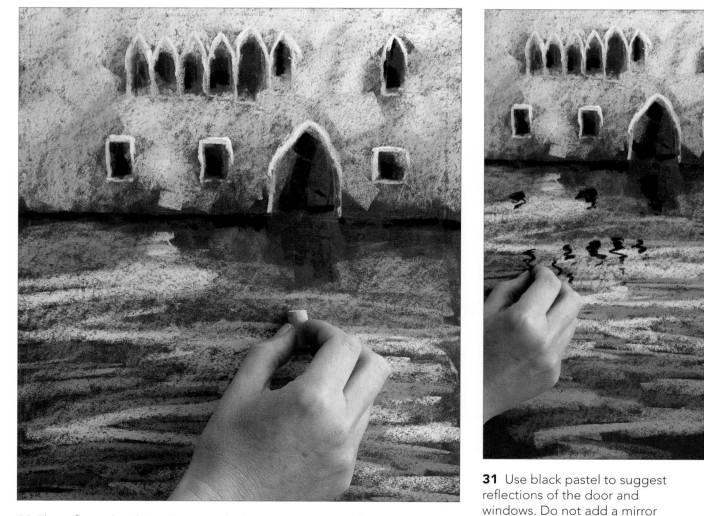

30 The reflected pinks in the water look too strong, so add Winsor yellow deep to knock them back a bit.

31 Use black pastel to suggest reflections of the door and windows. Do not add a mirror image – remember there is movement in the water.

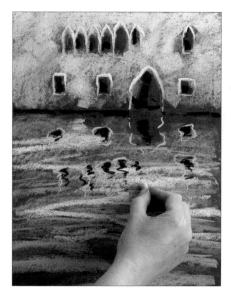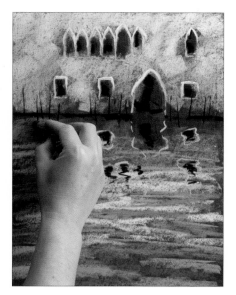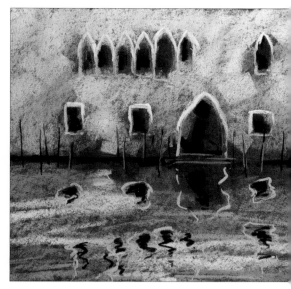

32 Paint reflections of the architectural details with raw sienna, breaking up the horzontal lines of the water.

33 Drag black pastel down over the water line to suggest the distant mooring poles.

34 Add Davy's gray tint 4 to one side of the poles and add a few horizontal lines to create a platform in front of the door.

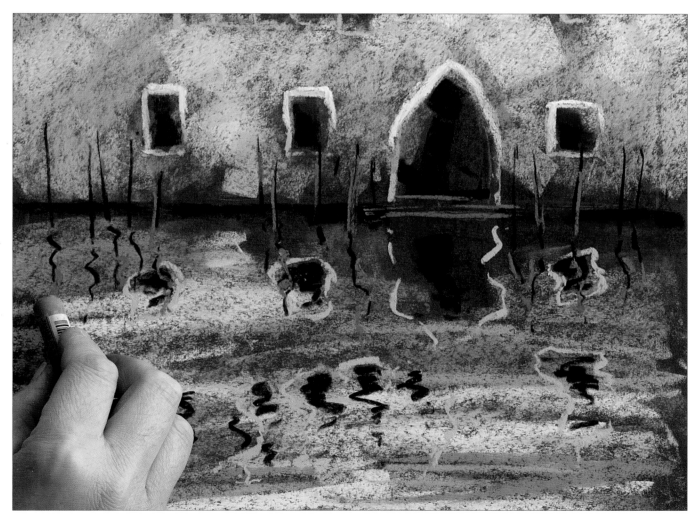

35 Paint the reflections of the mooring poles in the water with black pastel and then Davy's gray.

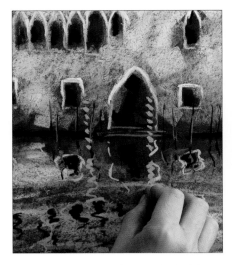 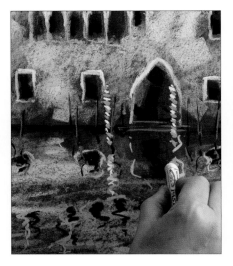 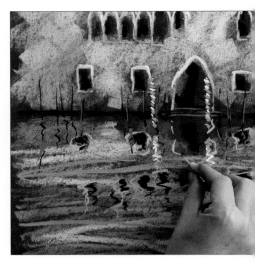

36 Use the end of the cobalt blue hue stick to make diagonal dashes, suggesting the colourful mooring poles and their reflections.

37 Add titanium white in the same way to the poles and their reflections.

38 Sweep over the water with horizontal strokes of the cobalt blue hue pastel to suggest the reflected blue of the sky.

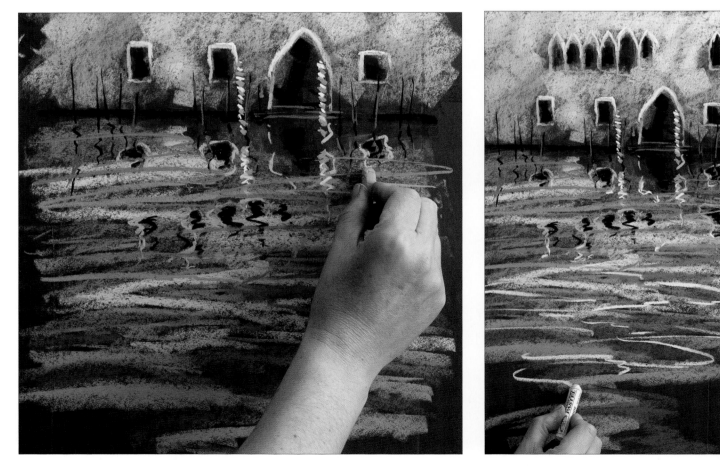

39 Apply more water effect strokes using oxide of chromium tint 2.

40 Use titanium white to create highlights where the sun catches the water.

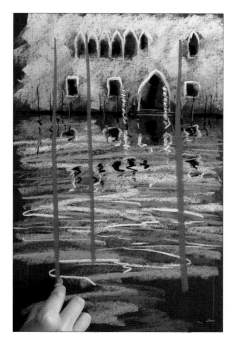

41 With bold linear strokes, put in the foreground poles with burnt umber tint 3.

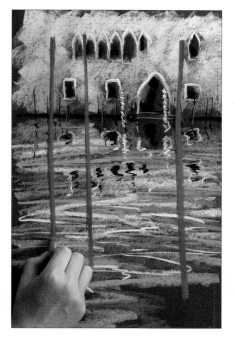

42 With raw umber tint 5, add a darker side to create a rounded form. Also add to the tops.

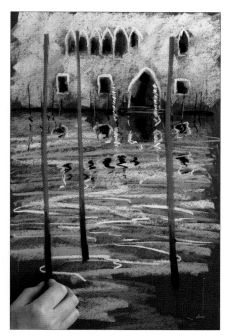

43 Apply black pastel firmly at the bottom of the poles and drag upwards, releasing the pressure as you lift off the pastel.

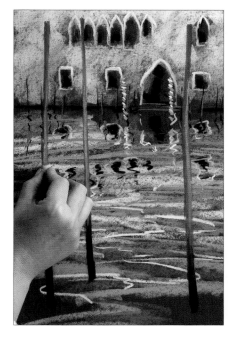

44 Lighten the middles of the poles with Winsor yellow deep.

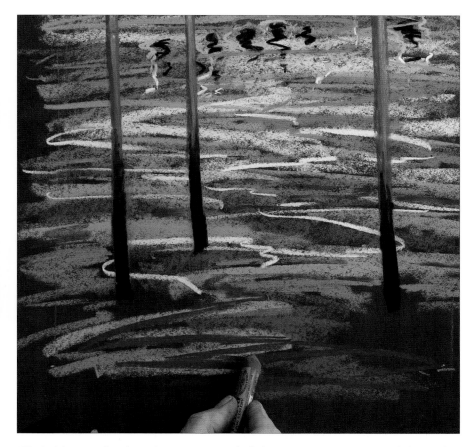

45 Add more fluid marks to suggest lightly moving water around the poles with the same blues and greens, then add the darker cobalt blue tint 4.

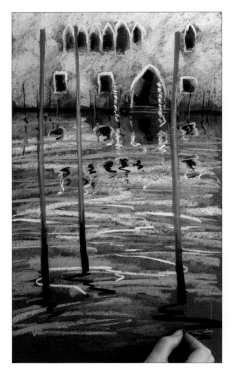

46 Paint the reflection of the black poles with zigzagging lines.

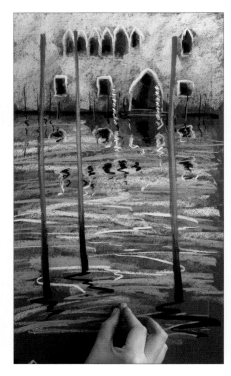

47 Add the reflected Winsor orange to the water.

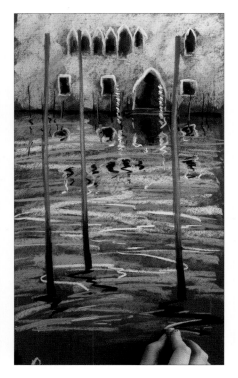

48 To add further vibrancy to the foreground, stroke in Winsor yellow deep.

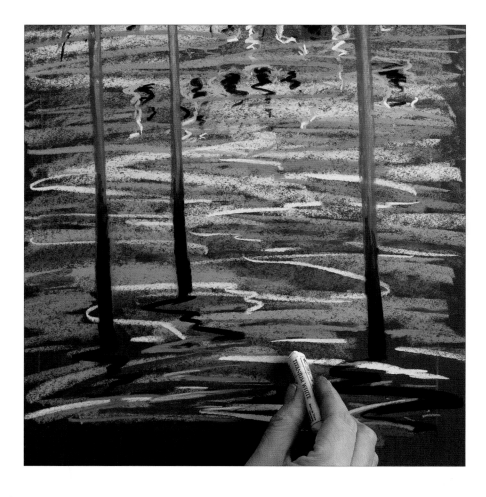

49 Finally add gestural, sweeping strokes of titanium white to add sparkle.

Opposite
The finished painting.

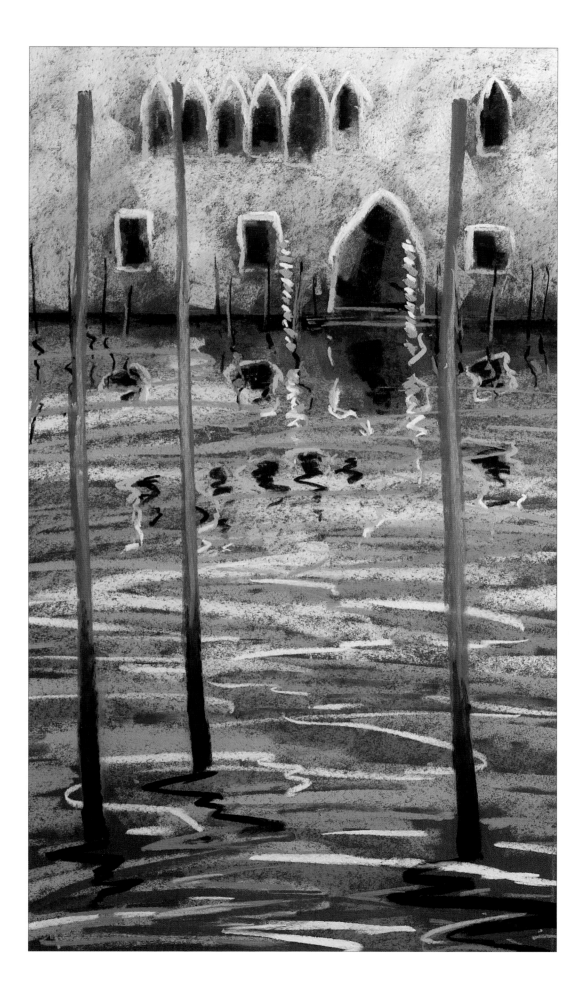

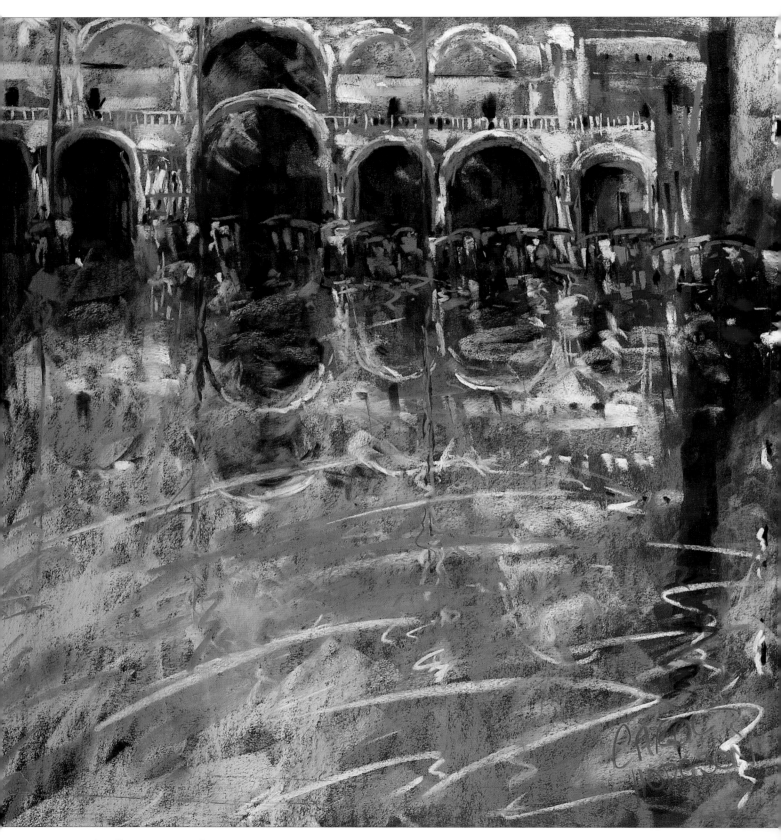

Umbrellas in St Mark's Square
39 x 39cm (15³/₈ x 15³/₈in)
This is painted on dark grey sandpaper, which allows the build-up of pigment without the use of fixative.

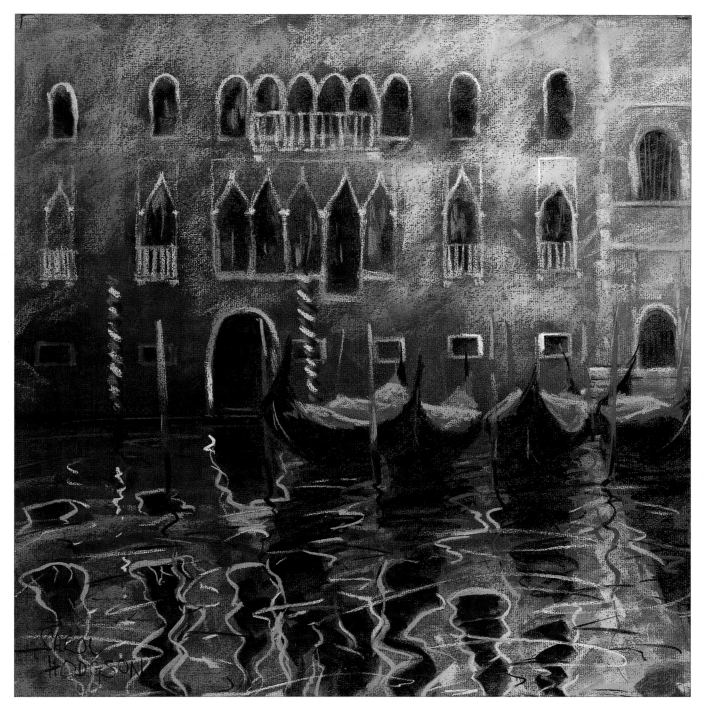

Four Gondolas
43 x 46cm (17 x 18¹/₈in)

The warm colours of the buildings contrast with the cool blue covers on the gondolas, the windows and the water. This was painted on green paper.

Index

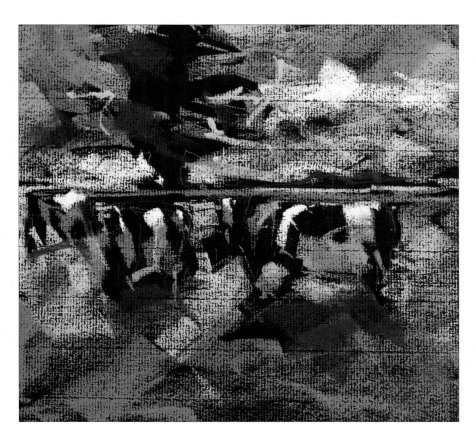

Derbyshire Cows
20 x 17cm (7⁷/₈ x 6³/₄in)

This painterly approach is a very useful technique for capturing a likeness quickly. With twists and turns of the pastel, I created an impression of cows grazing in a field. I left a lot of the black paper exposed to help create the shapes of the cows.